Goya

THE LIFE AND WORKS OF

GOYA

Janice Anderson

A Compilation of Works from the
BRIDGEMAN ART LIBRARY

SMITHMARK

Goya

This edition published in 1996 by SMITHMARK
Publishers, a division of U.S. Media Holdings, Inc.,
16 East 32nd Street, New York, NY 10016.
SMITHMARK books are available for bulk
purchase for sales promotion and premium use.
For details write or call the manager of special
sales, SMITHMARK Publishers, 16 East 32nd
Street, New York, NY 10016; (212) 532-6600
First published in Great Britain in 1996 by
Parragon Books Limited
Units 13-17, Avonbridge Industrial Estate
Atlantic Road, Avonmouth, Bristol BS11 9QD
United Kingdom

© Parragon Books Limited 1996

ISBN 0-7651-9895-9

Printed in Italy

Editors: Barbara Horn, Alex Stace, Alison Stace, Tucker Slingsby Ltd
 and Jennifer Warner

Designers: Robert Mathias and Helen Mathias

Picture Research: Kathy Lockley

The publishers would like to thank Joanna Hartleyat the Bridgeman Art Library
for her invaluable help.

FRANCISCO DE PAULA JOSE DE GOYA Y LUCIENTES
1746-1828

Francisco de Paula José de Goya y Lucientes was a gifted and versatile artist, with an approach to the techniques and subject-matter of painting which now seem to pre-figure, even to anticipate, the great art movements of the late 19th and early 20th centuries.

Francisco Goya was born on 30 March 1746, in the small village of Fuendetodos. On leaving school, he was apprenticed for a time to a local artist, José Luzan. He went to Madrid in 1763 to compete for a place at the Academy of San Fernando. Although he failed to win a place then, and again in 1766, he was able to continue studying painting in Madrid, notably in the studio of the court painter, Francisco Bayeu. Goya decided to widen his horizons, and in 1770 went to Italy. There, he was able to study at first hand the work of the great artists of the Renaissance.

Goya had more success in Italy than in Spain, winning a competition at the Royal Academy of Fine Arts of the City of Parma in 1771. With this recommendation, he returned to Spain, where he received his first commission, to paint frescos for the Pilar Cathedral in Saragossa.

By 1773, Goya was back in Madrid, where he felt sufficiently confident in the future to marry, choosing as his bride Josefa Bayeau, sister of the court painters Francisco and Ramon Bayeu. It was through Francisco Bayeu that Goya was commissioned by Anton Mengs, Director of the Royal Santa Barbara tapestry factory, to paint a series of cartoons which would form the basis of tapestries to be hung in a royal palace.

By 1780, Goya had made so strong an impression with his tapestry cartoons and other work that when he submitted his painting *Christ on*

the Cross, now in the Prado in Madrid, he was elected to the Academy of San Fernando. Two years later, he found a new patron in the Count of Floridablanca. Goya's portrait of the Count now seems stiff and formal when compared with the portraits that came later, but it got Goya's feet on the ladder to success.

In 1784, when the great Church of San Francisco el Grande was inaugurated in Madrid, Goya's magnificent alterpiece, *St Bernardin of Siena Preaching in the Presence of King Alfonso V,* was unveiled by Charles III. Two years later, Goya was appointed Court Painter.

The accession of Charles IV in 1789 saw no diminution in Goya's standing: his first royal portraits date from this time. The new king was more concerned with the Revolution in France than with art in his palace, however, and soon became suspicious of the liberal tendencies shown by some of his courtiers. Many, Goya's friends, supporters and patrons among them, were imprisoned or exiled. Goya himself gradually became disenchanted with the new court, where corruption and dishonesty seemed rife. Being a wise and cautious man, Goya said little, though he wrote to his friend Zapater expressing his dismay.

A grave illness in 1792 really changed the course of Goya's life and art. For several months, during part of which he lay paralysed and nearly blind, Goya's life was despaired of. Although he recovered, he was left stone deaf. As soon as he could, he was back at work. Among many notable works of this period was a set of eleven paintings for the Academy of San Fernando.

It was while Goya was recovering from his illness that his friendship with the Duchess of Alba grew. He stayed for a time at her country home and after the death of the Duke, the friendship seemed to turn into a much stronger relationship. By this time, Goya was Director of Painting at the Academy of San Fernando, having succeeded his brother-in-law, Francisco Bayeu in the post in 1795.

In 1798, Goya began work on what would become some of his finest paintings, a series of frescoes for the Church of San Antonio de la Florida. The theme was the life of St Anthony of Padua.

The years which followed were ones of great activity for Goya. His Caprichos etchings were being published and many more fine portraits were done. Then, in 1808, came the abdication of Charles IV and the invasion of Spain by French troops. The Spanish royal family was expelled and Joseph Bonaparte became king. Soon, Spain knew the horrors of war and civil war. Goya's long-held feeling that much of life was a tragedy seemed confirmed by these terrible events. In 1810 he began publishing his series of engravings, *The Disasters of War*, on which he later based several monumental paintings. Personal tragedy also affected Goya during the war years, for his wife died in 1812.

The year 1814 was to see the restoration of the Spanish royal family, in the person of Ferdinand VII. Although Goya was reinstated as Court Painter, his position was precarious for a time; he was even called before the Inquisition to answer charges of obscenity brought against *The Naked Maja* and *The Clothed Maja*.

After another serious illness in 1819 and now living near Madrid, Goya devoted himself to his sombre pinturas negras ('black paintings'), full of witches, demons and grotesque, mis-shapen people, and to the *Disparates* (or 'Proverbs'), a set of 22 etchings and aquatints.

For the present, it seemed as if Goya's disenchantment with life in Spain was complete. However, he changed tack again in the 1820s. Despairing of the repressive regime in Spain, in 1824 he asked Ferdinand VII's permission to go to France. Although he visited Paris and returned twice to Madrid, where Ferdinand VII directed Vincente Lopez to paint an official portrait of him, Bordeaux became his last home. There he painted several more fine portraits and there he died, on 16 April 1828.

▷ **The Parasol** 1777

Oil on canvas

THIS DELIGHTFULLY airy picture was one of a series of ten cartoons for tapestries that Goya did in 1777. The pictures, intended for the dining room of the Prince of the Asturias in the Palace of El Pardo, depicted costumes and pastimes of the period. Despite the aristocratic ambience for which they were intended, Goya did not hesitate to include a vulgar brawl outside an inn in one. There is nothing vulgar about the charming couple in this picture, however. The girl's elegant clasp on her fan and the well-bred lap-log curled on her knee, details seen in Goya's portraits of society ladies, suggest that this is a well-born couple, perhaps deliberately wearing the clothes of Spanish peasants. Taking part in masquerades was a popular pastime among the Spanish aristocracy in the latter half of the 18th century.

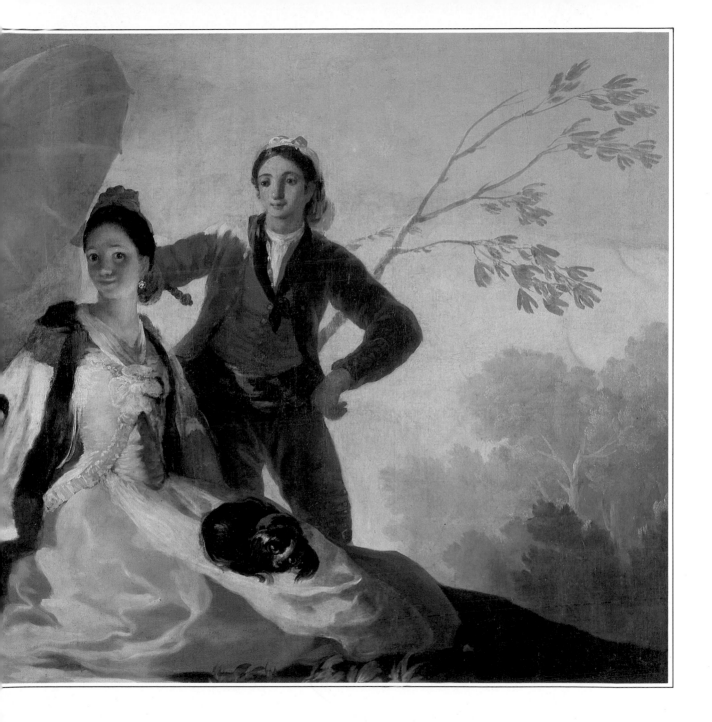

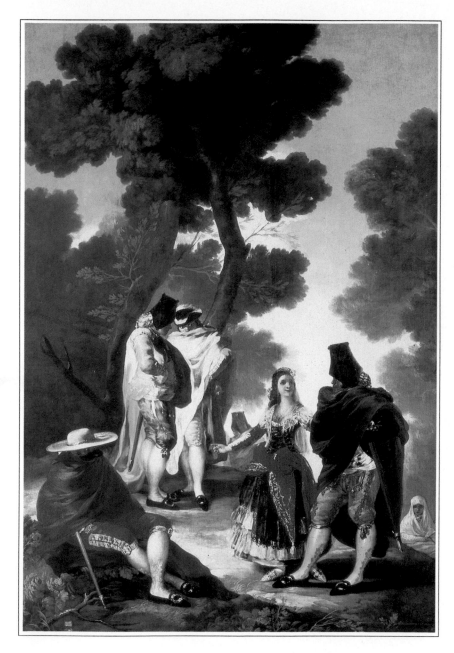

◁ The Maja and Gallants
1777

Oil on canvas

CHARLES III OF SPAIN was a
great lover of tapestries, but by
1773 was tired of the
conventions of Flemish tapestry,
with their ever-lasting genre
and mythological scenes. He
ordered the Royal Manufactory
to concentrate on themes such
as modern hunting scenes, with
people wearing everyday
Spanish costume. Goya's early
work benefitted greatly from
this edict, his tapestry cartoons
of the 1770s depicting smiling,
happy people engaged in the
many activities of contemporary
life. He described this picture,
another in the series done for
the royal dining room in the El
Pardo palace, as showing a
gipsy boy and girl strolling in
an Andalucian woodland of
pine trees; the atmosphere is
flirtatious, there may even be a
quarrel brewing among the
young men admiring the girl.
In fact, it is all very theatrical –
much like the popular operettas
which so delighted Madrid's
theatre-goers at this time.

▷ **The Pottery Vendor** 1778

Oil on canvas

BETWEEN 1775 AND 1792, Goya painted nearly 60 tapestry cartoons, all of them inspired by the rich life of contemporary Madrid, which he experienced on every level. This light-hearted picture of an outdoor crockery saleswoman is typical of them, both in its portrayal of everyday life, with the working people of the town and the gilded aristocracy apparently happy to rub shoulders in their daily lives, and in its clean lines and simple shapes, so necessary to the technical requirements of the men who would weave the tapestries. Goya's insistence on painting reality as truthfully as he could, at a time when much court painting was given over to what was artificial and false, was getting him noticed. In 1779, the year after he painted this picture, Goya was received at court.

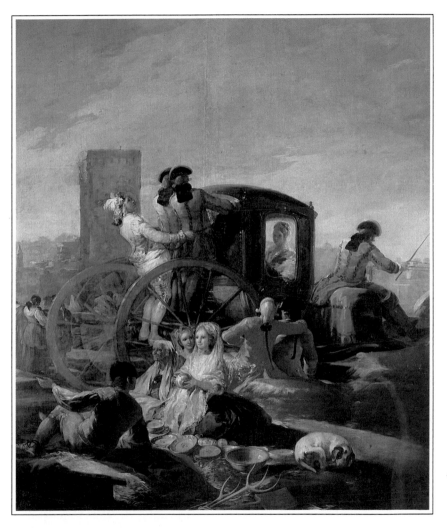

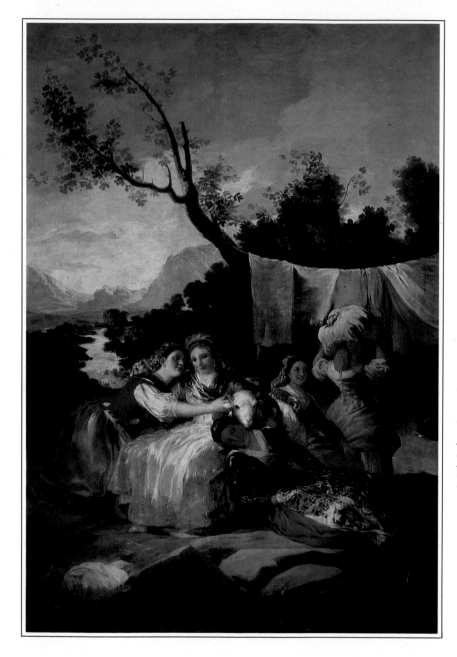

◁ **The Washerwomen** 1780

Oil on canvas

THIS IS ANOTHER of the paintings Goya did as cartoons for tapestries designed for El Pardo palace. Goya himself described the colours of this picture as gay, the pinks and blues which dominate it being particularly bright. Once again, it is an attractive scene, the women are relaxing happily by the river after their day's work. There is a greater emphasis on landscape in this cartoon than in others Goya had done up to this time. Art historians think that Goya was probably painting a real scene, with the river being the Manzanares, which wound its way through the outskirts of Madrid. The church of the washerwomen of Madrid, San Antonio de la Florida, which Goya was later to decorate, was built on land near the banks of the river.

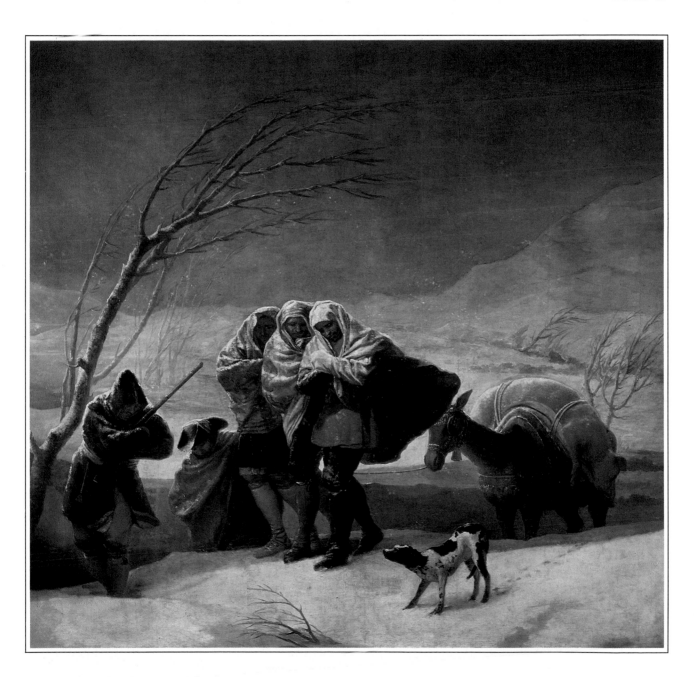

The Snowstorm 1786-7

Oil on canvas

◁ *Previous page 13*

THE ONLY WINTERY snow scene among Goya's sixty or so cartoons, this picture was designed for the dining room of El Pardo. Although Goya has composed a cold, bleak picture, he has still given it an optimistic tone: the peasants are well wrapped against the bitter wind, and the carcase of the pig slung over the mule's back suggests that the peasants and their families are going to be well-fed in the near future. The cartoon clearly found favour with Goya's masters, for several tapestries were woven from the design, one of which found its way into the dressing room of the Infante Don Francisco.

▷ **Autumn: The Vintage** 1786

Oil on canvas

THIS STYLISH CARTOON was probably painted by Goya while he was staying at the Duke and Duchess of Alba's country estate, Piedrahita, in the country near Avila. Goya painted a companion picture, *Summer: The Harvest*, at much the same time, and it is possible that the working life of the Alba estate gave him all the inspiration he needed to complete the two lively and elegant pictures. Not highly valued in its day – only one tapestry was woven from the design – this picture is now among the most admired of all Goya's tapestry cartoons.

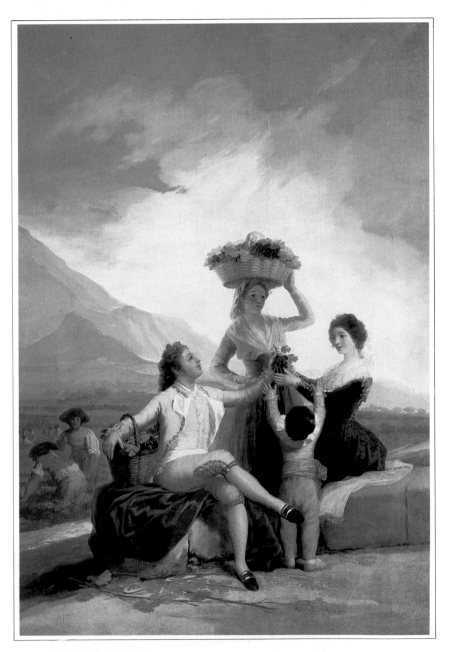

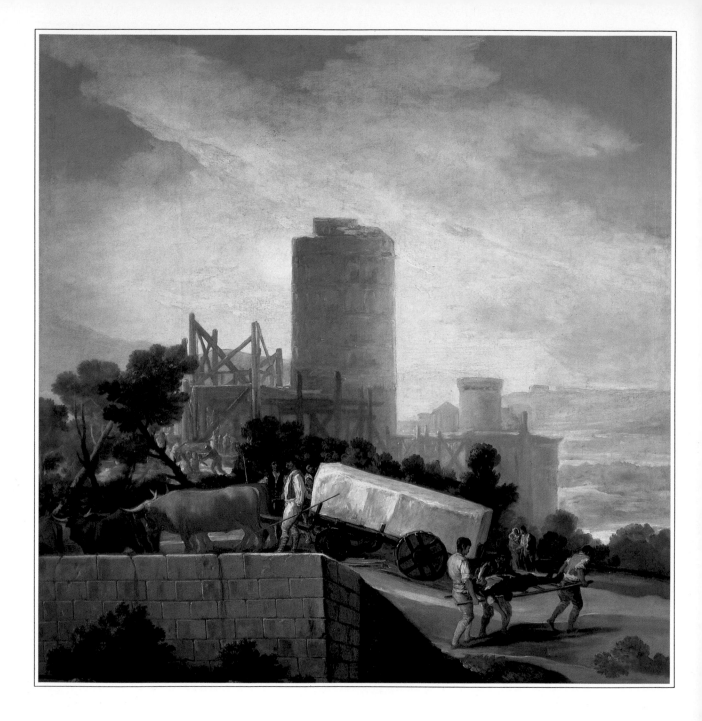

◁ **Transporting a Stone Block** 1786-7

Oil on canvas

THIS PICTURE WAS one of a number commissioned for hanging in the Alameda, the country house of Goya's patron, the Duke of Osuna. Although all the pictures were intended to be views of everyday life in the country, Goya gave this one a gloomy overtone far removed from most of his light-hearted tapestry cartoons of the late 1770s. Goya seems to be telling us that building in stone is hard work, and injuries are all too likely. There is a tapestry cartoon of this same subject in the Prado in Madrid, to which Goya gave the title 'The Injured Mason', thus highlighting a less happy aspect of the working life. In his own description of the painting Goya made it clear that here he intended to emphasize the hard reality of being a labourer, in great contrast to many of his other, jollier, pictures of contemporary working life in Spain.

The Meadow of San Isidro 1788

Oil on canvas

▷ *Overleaf pages 18-19*

THE SPIRES, TOWERS and walls of the great city of Madrid, bathed in the glorious light of early summer, dominate the skyline of this superb landscape. Goya's painting is really a preliminary sketch for a tapestry cartoon, probably at least partly done in difficult conditions on the spot, but the effect is impressive, particularly in the way he renders the clear light bathing the scene. His picture captures all the holiday spirit integral to the celebration of the Fiesta of St Isidro, patron saint of Madrid, on 15 May. It is thought that Goya may have got his inspiration for this picture from a short theatrical sketch by the Spanish playwright Ramón de la Cruz, which told how two young servants abandoned their household tasks to join in the 15 May festivities. Goya would seem to have been carried away by his subject: his picture was so complicated, so full of people and movement, that it was never made into a tapestry.

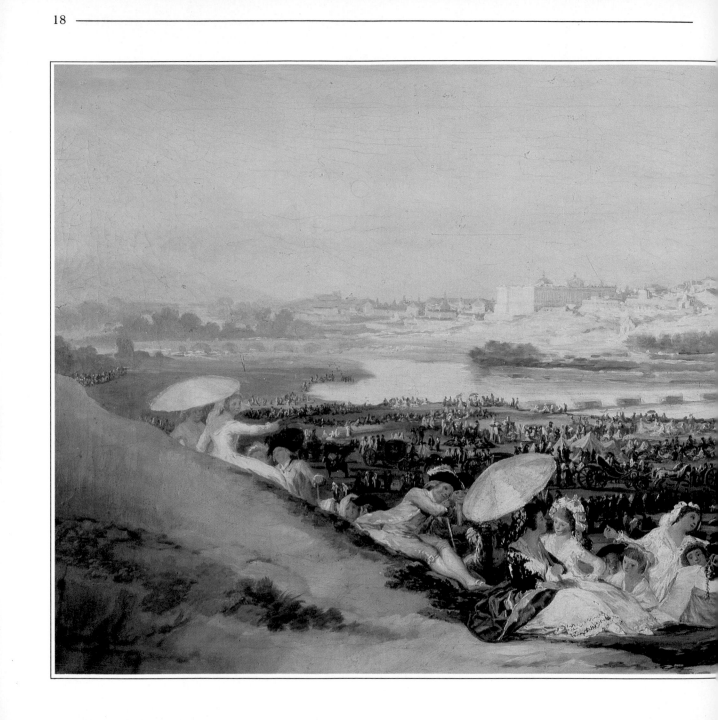

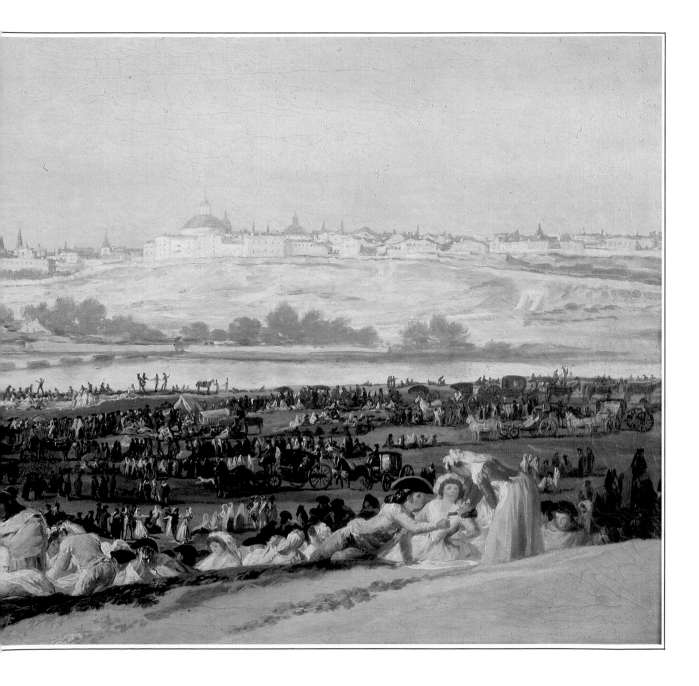

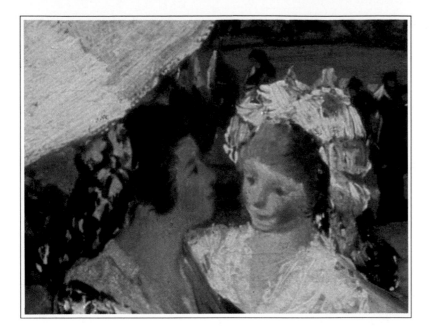

△ **The Meadow of San Isidro** (detail)

SOME TEN YEARS BEFORE he painted this picture, Goya was able to study in great detail the paintings by Velázquez in the royal collection while making a series of engravings based on them. He himself said several times that his own work owed much to what he had learned 'from studying Velázquez'. In this painting, the first in which Goya could be said to have made his mark as a major painter in his own right, the debt to Velázquez may be seen in the broad treatment of the groups of figures and in the way in which they have been scattered across the composition, almost as if they were part of the landscape. Goya said of this painting that it had been 'the most difficult thing I ever did.' The delightfully light-hearted group of charming women and their escorts in the foreground gives no hint of Goya's difficulty.

▷ **Blind Man's Buff** c.1789

Oil on canvas

AT THE TIME he produced this painting, yet another tapestry cartoon, Goya was coming to the end of the early, carefree, wonderfully successful part of his long career. While 1789 was the year in which he was appointed Court Painter by the new king, Charles IV, it was also the year of the French Revolution, and the atmosphere of the Spanish court became markedly less liberal as a result of what they saw happening north of the Pyrenees. Goya, too, was growing older, more mature, with a wife and child to think about. From now on there would be fewer of such carefree pictures as this charmingly detailed picture of children playing the age-old game of Blind Man's Buff.

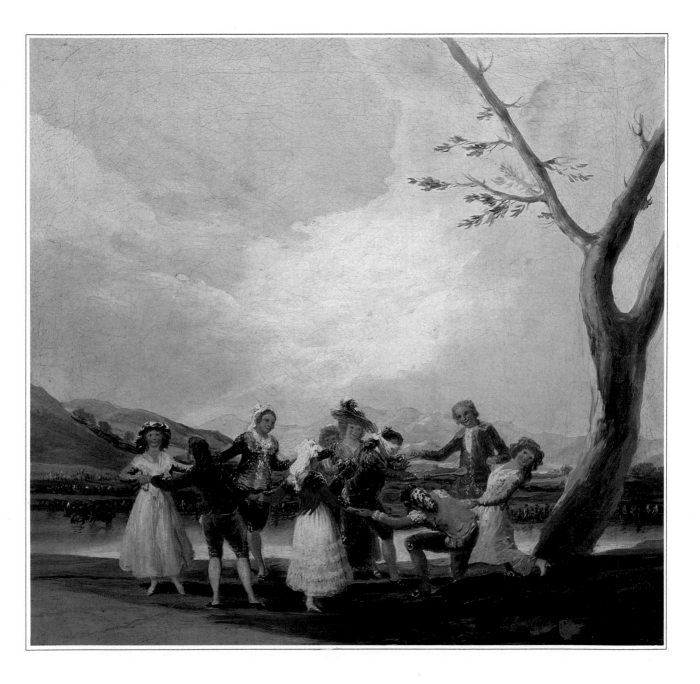

▷ **The Wedding** 1791-2

Oil on canvas

SATIRE REPLACES the charm of innocence in this marvellously observed picture of a village wedding: the bride is young and lovely, her richly dressed groom an ugly buffoon. It would seem that the pair are making an unromantic marriage of convenience: a theme which Goya would use again in later pictures. The clear, bright colours and strong lines of the composition indicate that this is another tapestry cartoon; in fact, it was part of Goya's last series of such cartoons, and was intended for the Palace of San Lorenzo. There is a strong element of the theatrical about the picture, both in the sharply characterized faces and attitudes of the people surrounding the couple and in the stage set treatment of the background and its lighting.

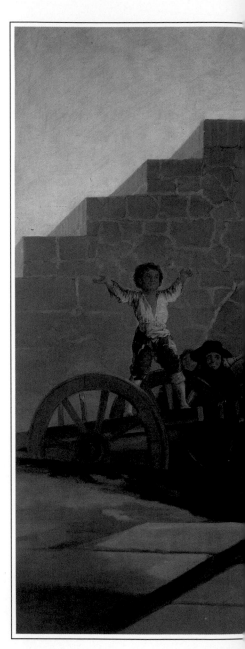

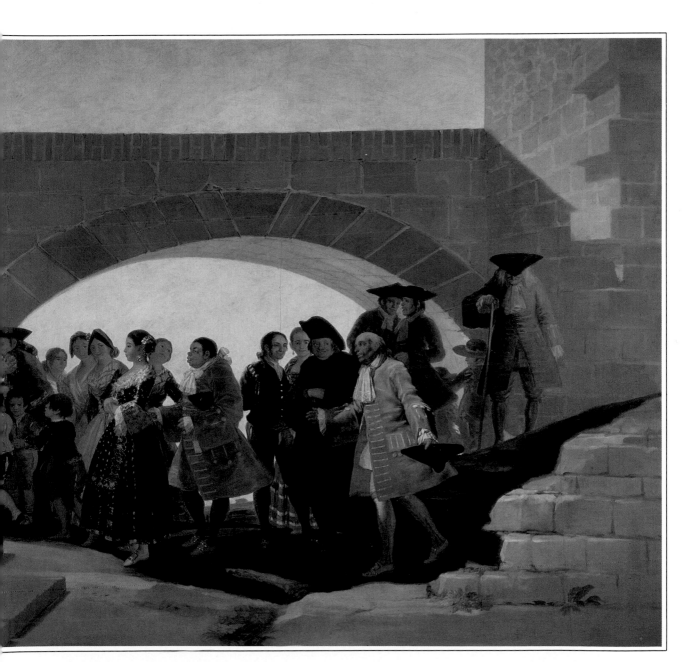

▷ **The Wedding** (detail)

THE SMALL BOY standing on the cart, arms in the air, on the left of *The Wedding* is a typically Goya creation: he, or perhaps his brother, may be seen again in another tapestry cartoon, *Pick-a-Back,* still with his arms waving in the air, despite the fact that he is sitting on another boy's shoulders. Goya seems to have taken a particular pleasure in painting children at this time, when his own son, Xavier, would have been about seven years old. Of all Goya's five children, Xavier was the only one to survive childhood.

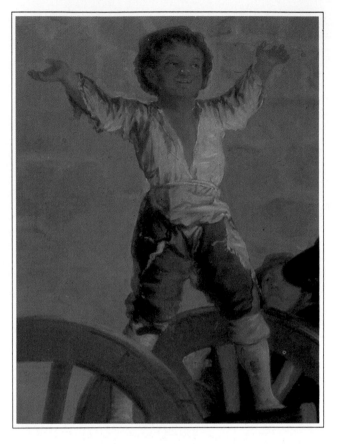

▷ The Straw Mannequin
1791-2

Oil on canvas

THIS WAS ONE OF Goya's last tapestry cartoons and, as he informed the King, his employer, represented four women tossing a masked dummy dressed in men's clothes. He was doing more than just depicting a jolly game. Spanish emblem books of previous centuries had made clear the significance of such scenes: one might have personal power over a doll or a puppet, but it would be brief. For women, in particular, playing with men was to behave foolishly, for they were likely to end by being cheated. The folly of women was a theme Goya would return to again, notably in one of his *Los Disparates* drawings of the 1820s.

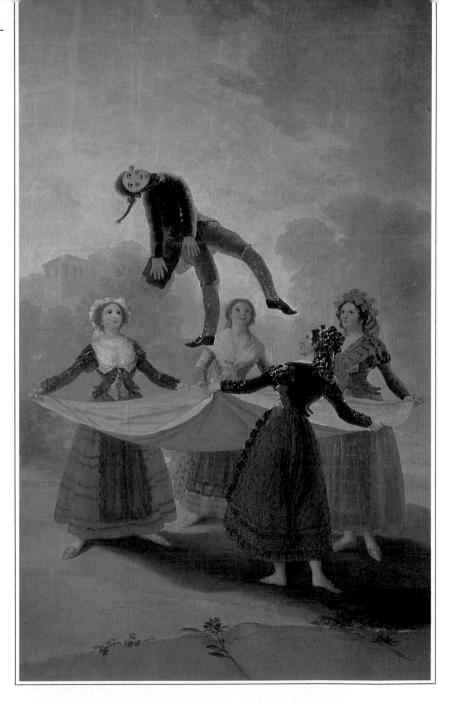

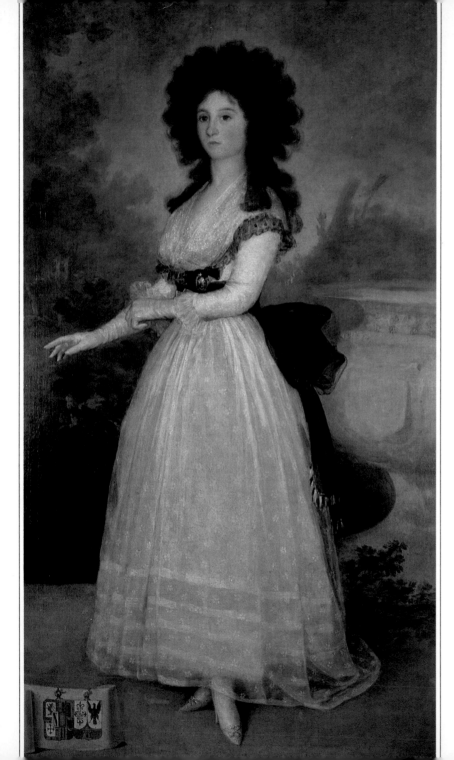

◁ **Dona Tadea Arias de Enriquez** c.1793-4

Oil on canvas

ALTHOUGH THIS WAS the first large-scale, full-length portrait Goya painted after the terrible illness of 1792-3 had left him profoundly deaf, there is no sign here of any diminution of his mastery of the portrait form. While it is in some ways a conventional enough treatment of the subject – an outdoor setting suggesting large estates, with a classical urn in the background and the subject in elegant and, no doubt, expensive attire, all much in the style of a portrait by Joshua Reynolds – this portrait has a splendid presence. There is an imperious look in the girl's eye as she draws on her elegant muslin glove made, probably, from the same delicate fabric as her overskirt, while the coat of arms on the scroll at her feet leaves us in no doubt of her aristrocratic origins.

▷ The Marquesa de la Solana
1794-5

Oil on canvas

THIS SUPERB portrait, a relatively simple composition in shades of grey with touches of pink to lighten it, demonstrates why Goya was the greatest portrait painter of his generation – and of several generations to come. It is an extraordinarily honest portrait of a formidable lady. The Marquesa de la Solana was also the Condesa del Carpio and, from historians' accounts, a proud and characterful lady and this picture is made with great respect but with no attempt to flatter. The Marquesa stands straight-backed and totally composed, gazing out from the picture with a certain, characteristically Spanish melancholy in her dark eyes. Not content with showing merely the outward form of his sitter, Goya has produced a magnificent study of character.

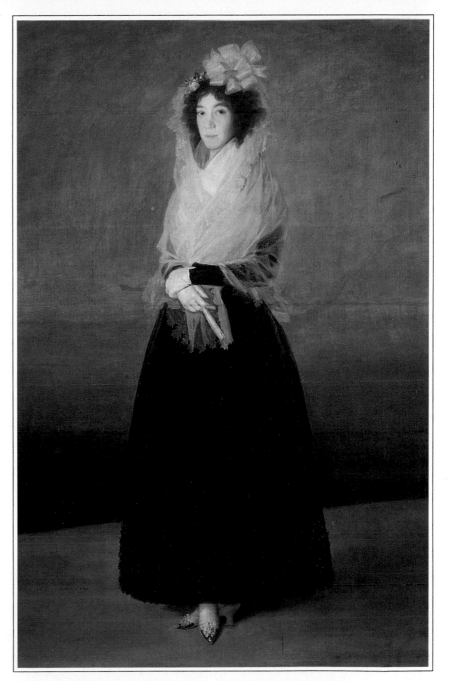

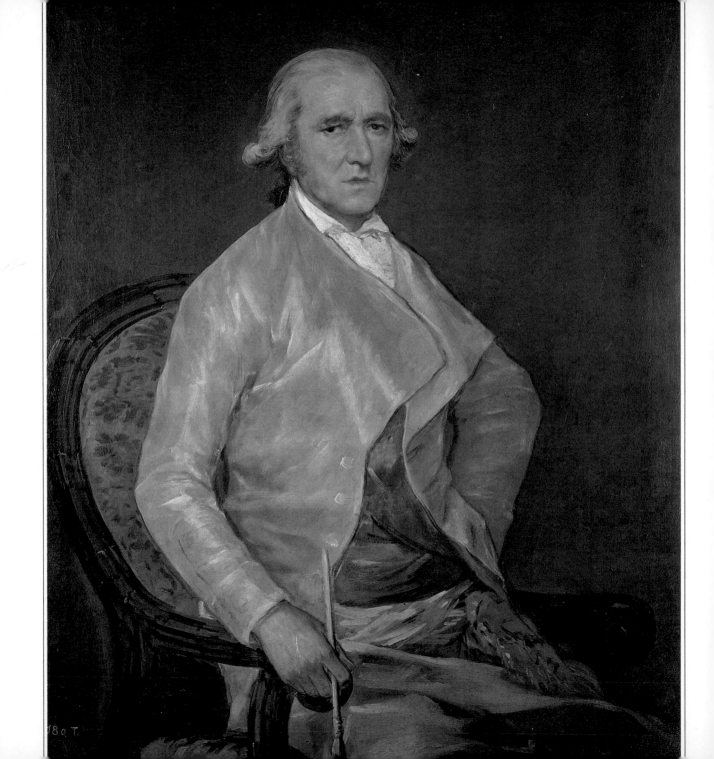

◁ **Portrait of the Painter, Francisco Bayeu** 1795

Oil on canvas

ONCE AGAIN, GOYA has chosen a silvery grey as the main colour for this fine portrait, a study of his brother-in-law which may also have been Goya's final homage to Bayeu, who died in the year this portrait was painted. Goya's feelings towards his brother-in-law were always mixed: he was grateful for the older man's patronage in his early years of struggle as a painter, but he was also irritated by Bayeu's air of finicky self-importance. This ambivalence of attitude clearly shows in the portrait, whose face is that of a rather straight-laced and disapproving man, but who has been portrayed with the mastery of touch and use of colour for which Goya was unrivalled.

The Duchess of Alba 1795

Oil on canvas

▷ *Overleaf page 30*

THE DUCHESS OF Alba, 33 years old in 1795, beautiful, immensely aristocractic and wealthy was, like the Duchess of Devonshire in England at the time, notorious for the scrapes she got into, the lovers she was supposed to have had and the pleasure she had from mixing with Madrid's artistic set. She even wore the fashions of the *majas* of the time. Although the fact has never been proved, it would seem that for some time, probably after the death of the Duke of Alba in 1796, the Duchess and Goya were lovers. Certainly, there is a great intimacy about this famous portrait: the duchess is pointing towards an inscription, traced on the ground at her feet, which reads 'A la Duquesa de Alba. Fr. de Goya 1795', and the gold bracelet on her left arm bears the initials 'F.G.'

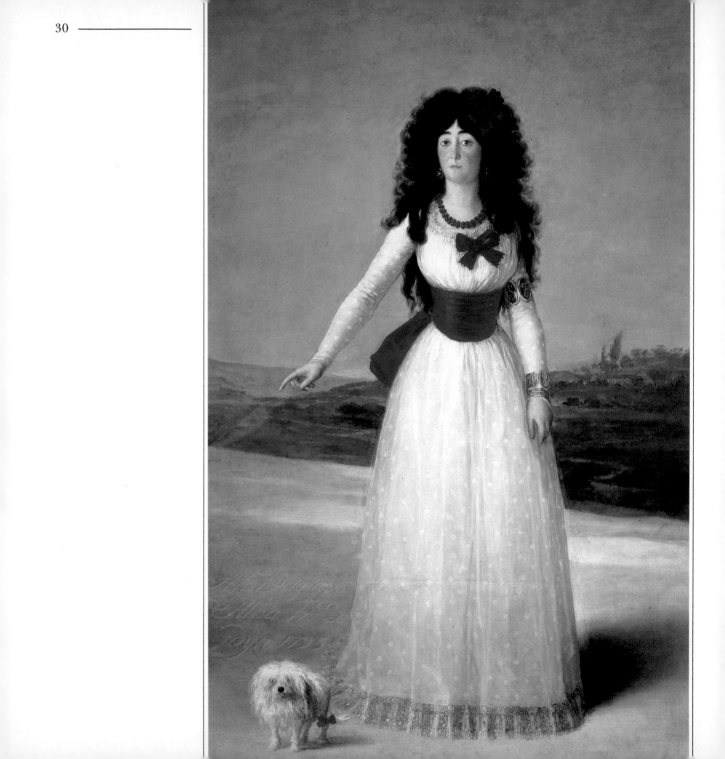

▷ **Self-portrait in the Studio**
1794-5

Oil on canvas

GOYA PAINTED HIS own portrait
many times, sometimes in the
background of larger pictures,
as in the well-known group
portrait, *The Family of Charles
IV,* and often in unusual
situations: one of the most
famous, painted in 1820 when
he was 74, shows him as he
had been a few months before,
desperately ill, in the arms of
his doctor. This self-portrait is
of a much younger Goya,
apparently in good health,
though there is a rather
careworn expression on his
face, as if the strain of the
complete deafness which now
afflicted him was considerable.
Goya seems also intent on
showing us the trappings of a
successful man – which,
indeed, by this period in his
life he certainly was. He shows
himself in a richly ornamented
jacket and wearing a smart
hat, while the pierced tray with
its bottles (possibly a writing
set) is clearly silver.

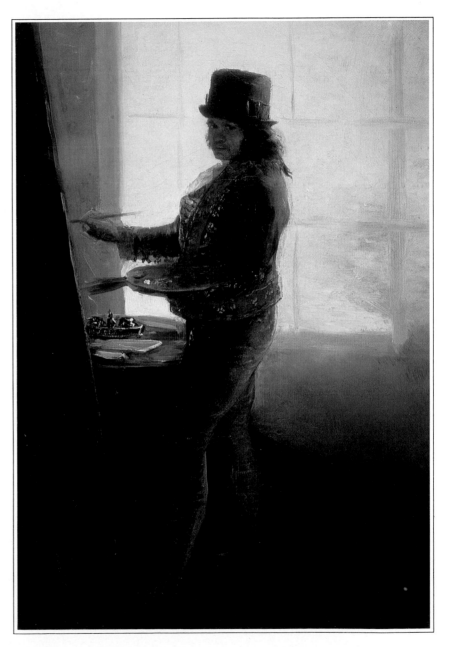

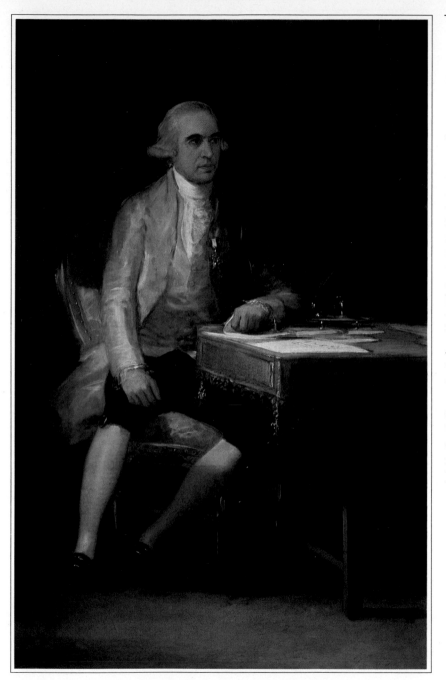

◁ **Portrait of Don Francisco de Saavedra** 1798

Oil on canvas

THIS IS AN OFFICIAL portrait (Francisco de Saavedra was Secretary of State in a liberal government in Spain in 1798) and therefore somewhat formal in style. Even so, there is nothing of a restrained nature about Goya's portrait of the man. The face, with its dark eyes and strongly marked black brows, dominates the picture, despite the richness of the minister's blue satin coat. Although it was one of many official portraits Goya painted during the latter years of the 1790s, there is nothing slapdash or characterless about this portrait; rather, it is a fine example of the work of a master portrait painter at the height of his powers.

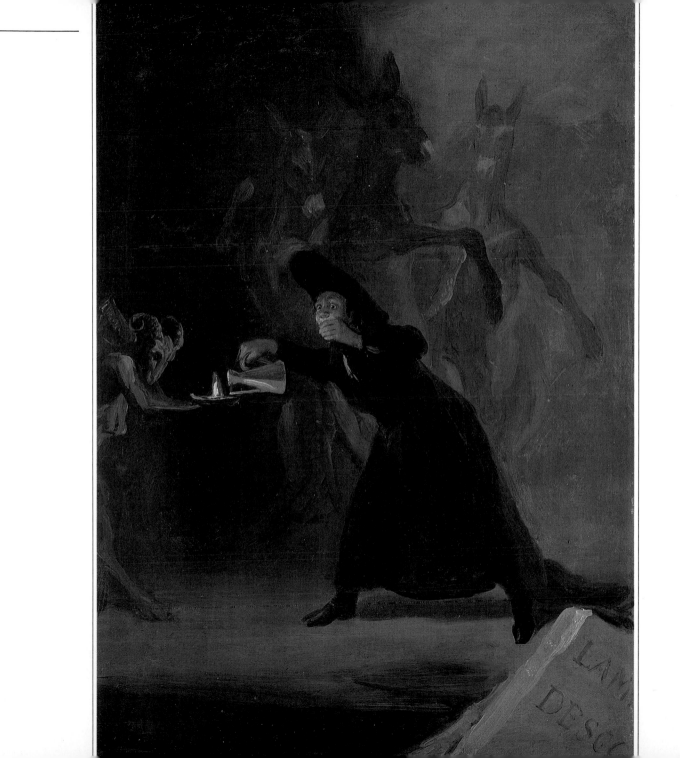

The Bewitched 1797-8

Oil on canvas

◁ *Previous page 33*

IN 1797-8, GOYA painted six witch pictures for his patron, the Duke of Osuna. The duke paid the surprisingly large sum of 1000 reales each for them. More light-hearted than the frightening pictures of witches Goya produced later, the six were all composed as if against a theatrical backdrop. Three of the pictures, including this one, actually illustrated scenes from popular plays. The play chosen here was *El Hechizado por Fuerza* ('Bewitched by Force') by the 17th-century dramatist Antonio de Zamora. The picture shows a burlesque priest, believing himself to have been put under a spell, pouring oil into a lamp held by a devil in the form of a goat. Goya, as well as indulging his love of the theatre, is satirizing the superstition and ignorance of much of the Spanish priesthood of his time.

▷ Josefa Bayeu, the Artist's Wife 1790-98

Oil on canvas

GOYA MARRIED Josefa Bayeu, sister of his master and patron, Francisco Bayeu, in 1773 in Madrid. Since Francisco Bayeu was Court Painter at the time and therefore a useful contact, it is generally assumed that Goya married as much for professional prudence as for romance. This delicately charming picture, so different in tone from Goya's forceful and aristocratic portraits of the great ladies of his day, indicates at least a considerable affection for his wife on Goya's part. The couple had five children, only one of whom, their son Xavier, born in 1784, survived to adulthood. Josefa died in 1812.

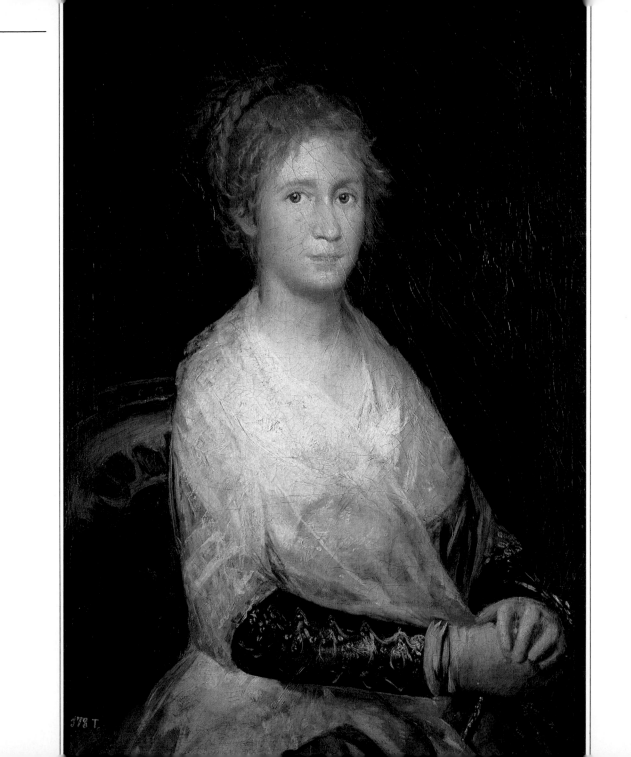

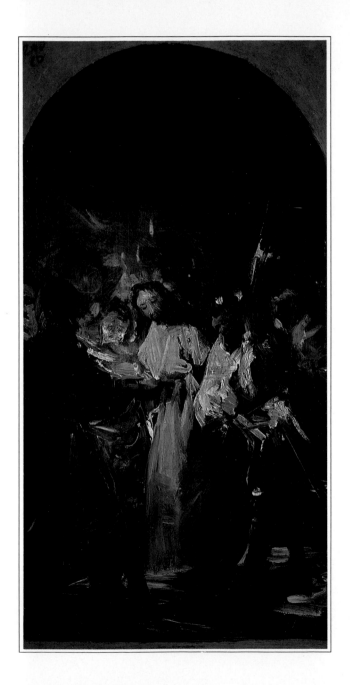

◁ **Christ's Arrest in the Garden** c.1788-98

Oil on canvas

THIS EXTRAORDINARILY atmospheric little picture is probably an early sketch for a work commissioned from Goya by the Archibishop of Toledo for hanging in the sacristy of Toledo Cathedral. Goya was known to have been working on the main picture for many years before it was finally delivered to Toledo Cathedral in January 1799, and this sketch could have been done any time from the late 1780s, when the work was first mooted. It is probable that Goya took so long over the painting because he was deeply conscious of the significance of its intended hanging place, as a companion to El Greco's superb *Disrobing of Christ,* which had been one of the glories of Toledo Cathedral for more than 200 years. In this sketch, Goya has laid his paint on in thick streaks of colour, using pale shades to set the deeply moving figure of Christ apart from the soldiers who have come to lead him to his crucifixion.

▷ **The Condesa de Chinchón**
1800

Oil on canvas

THE CONDESA DE Chinchón
had been just a child, the four-
year-old daughter of the
Infante Don Luis de Borbón,
when Goya first painted her, as
one in a family group. Now
the child has grown up, is
married and is expecting a
child of her own. But Goya
knows too much of the
background to her life at the
Spanish Court to be able to do
a typical society portrait of a
great lady. The Condesa was
married in her teens to
Manuel Godoy, a former
Guards officer risen to great
heights as favourite of both the
king, Charles IV and his
queen, the loathed Maria
Luísa, whose paramour Godoy
was said, probably wrongly, to
be. In this wonderfully tender
portrait, painted by an artist at
the height of his powers as a
portrait painter and using the
glorious silver tones which
marked his finest portraits,
Goya conveys his sympathy for
the innocent girl, forced to live
in humiliating circumstances
in a corrupt court.

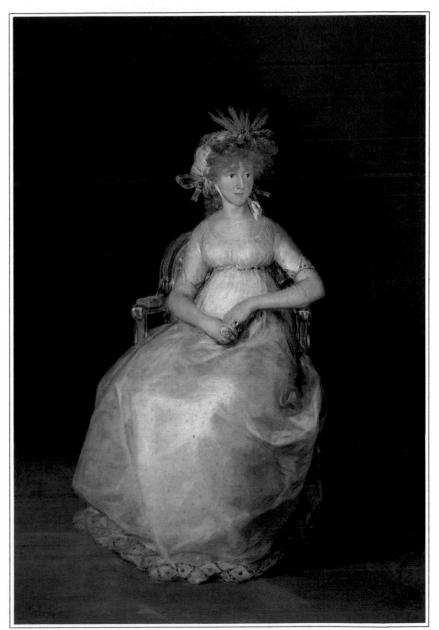

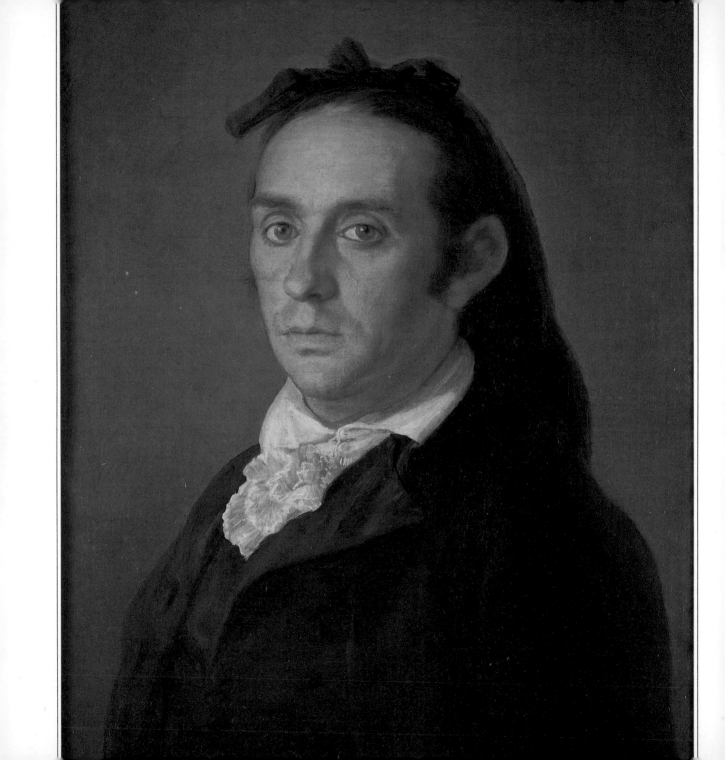

◁ **The Matador Pedro Romero** c.1800

Oil on canvas

GOYA WAS KEEN on bullfights, and numbered among his friends in Madrid many bullfighters. His numerous portraits of bullfighters were all painted with a sympathetic boldness. Pedro Romero, one of the most famous *toreros* of Goya's day, came from a very well-known Andalucian bullfighting family; his brother, José, was also a bullfighter. Pedro Romero was painted several times by the artist, while 19th-century copies of Goya's portraits of him are numerous. This portrait would seem to have been done some time after Romero had retired from the bullring in 1798: there is a rather tired, even middle-aged look about this man which is quite different from the tense, keen-eyed bullfighter at the height of his powers, whom Goya had painted in the mid-1790s.

▷ **The Madhouse** c.1800

Oil on wood panel

▷ *Overleaf pages 40-1*

AT FIRST GLANCE this is a typically 18th-century view of an asylum: the crazy, naked figures, some of them clearly believing they are kings, or perhaps an Indian brave, being looked at by members of the public behaving like spectators at a fairground side show, builds up to a picture strongly reminiscent of the Bedlam scene in Hogarth's *The Rake's Progress*. But Goya's picture is more horrific than Hogarth's, because Goya's painting conveys the pity the artist feels for the sufferings of the inmates of the madhouse. The clear grey light of the sky, glimpsed through the barred window, seems to emphasize the dark corners of the interior, whose shadows mirror the darkness in the minds of all who end up in this terrible place.

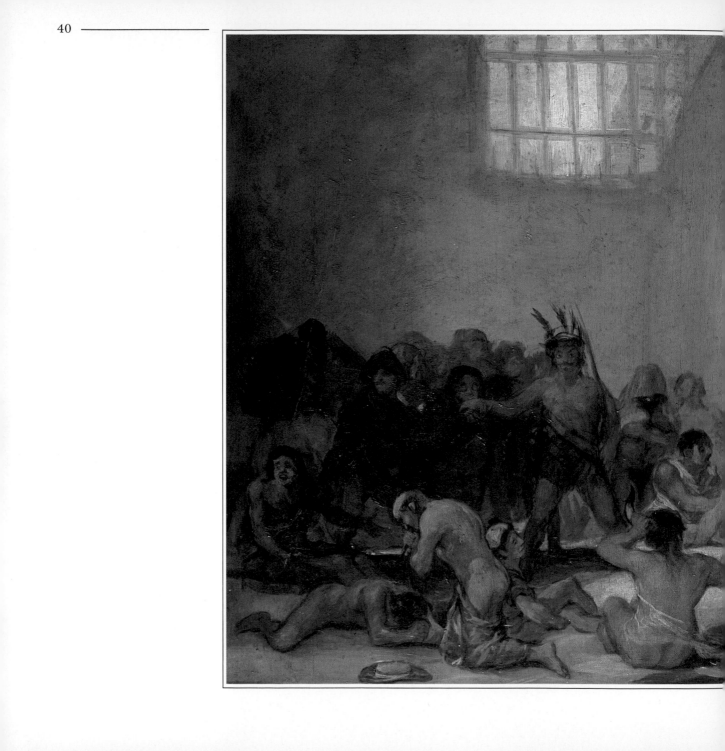

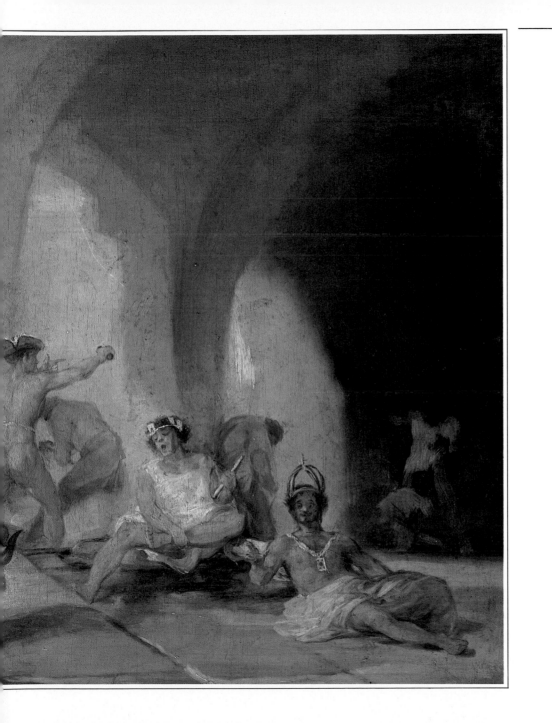

▷ **The Naked Maja** 1800-5

Oil on canvas

THE NUDE IN Spanish painting
is a rare thing. As painted by
Goya, it is sensational. Its
frank realism, probably the
result of Goya's desire to paint
a nude unencumbered by
mythological or classical
associations, caused the
painting and its companion
study, *The Clothed Maja,* to be
condemned as immoral and
obscene by the Holy Office in
Spain. It is not known exactly
when Goya painted the two
pictures, although they are
listed among the pictures of
Manuel Godoy in 1808.
Although rumour has linked
the Duchess of Alba to this
picture, it seems highly
unlikely that it was anyone
other than a courtesan who
posed for it. The most likely
link between the Duchess and
the painting lies in her
ownership of Velázquez's *The
Toilet of Venus* (known as *The
Rokeby Venus,* now in the
National Gallery, London), for
if Goya's naked woman has
any precedent, it is surely
Velázquez's equally sensational
Venus.

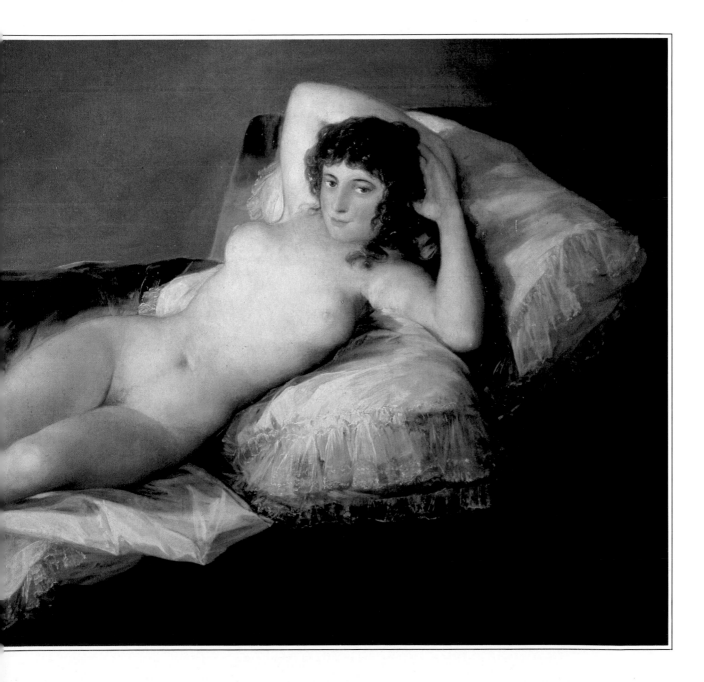

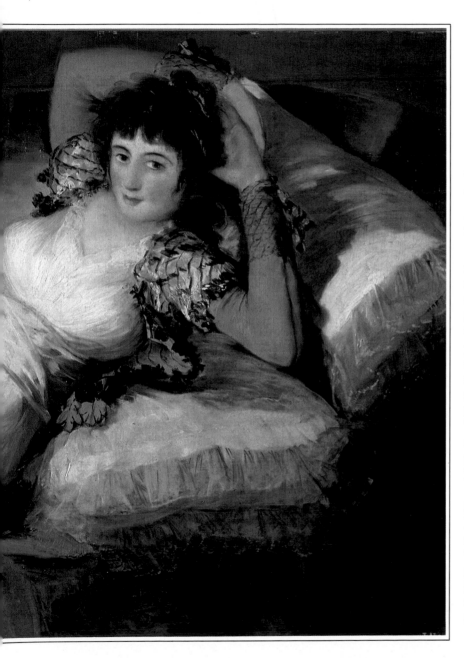

◁ **The Clothed Maja** 1800-5

Oil on canvas

GOYA HAS CHOSEN to put his clothed *maja* in Moorish-style dress. Her clothing seems more suggestive than the frank nudity of the picture's companion painting, *The Naked Maja*. It is also painted much more boldly. Both paintings were at one time in the private collection of Manuel Godoy, one of the most powerful figures in the court of Charles IV and a considerable patron of the arts. It is possible that it was Godoy who commissioned the pair of paintings – a commission which could account for the unusual sensualness of Goya's treatment of their subjects. When Godoy's property was confiscated by the state during the repression which followed Ferdinand VII's restoration in 1814, Goya was summoned before the Tribunal of the Inquisition to say whether or not he had painted these 'obscene' works. His reply is not known. It is possible that influential friends ensured that Goya was not harassed over the matter.

▷ **The Colossus** 1808-12

Oil on canvas

SPAIN HAD BEEN at war with the France of the Emperor Napoleon when Goya painted this powerful picture, which was probably executed while Napoleon's brother Joseph ruled Spain. Goya is thought to have been inspired by some lines of the poet Juan Bautista Arriaza, written about the Napoleonic Wars:

Detail

> *On a height above yonder*
> *cavernous amphitheatre a*
> *pale Colossus rises...;*
> *the Pyrenees are a humble*
> *plinth for his gigantic limbs.*

Goya was deeply affected by the way in which the horrors of war were being visited on his country and the consequences for his art were considerable, with many extraordinary works emerging from his studio. *The Colossus* was an early example of an obsession with the gigantic, which was a theme of Goya's later work.

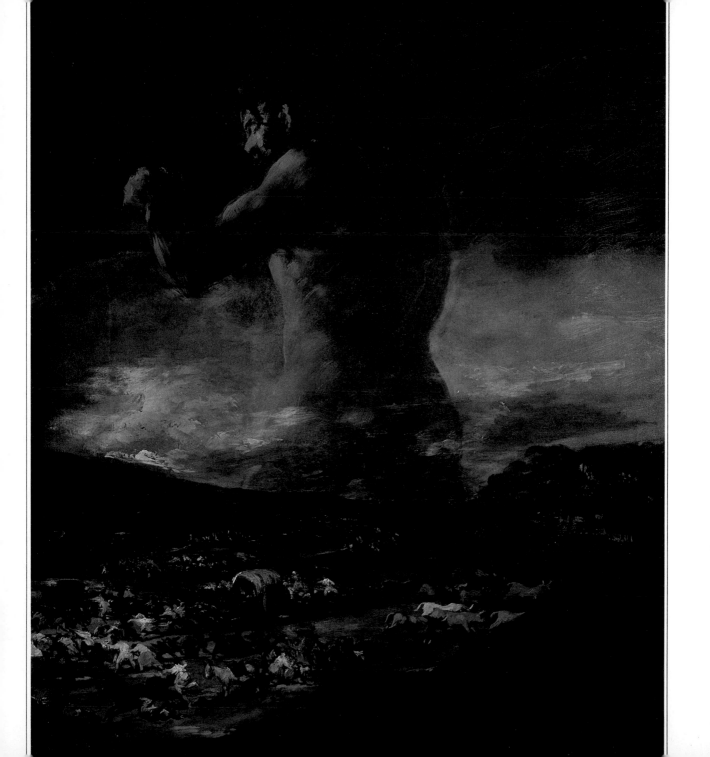

▷ **The Village Bullfight** 1808-14

Oil on wood panel

THE DATE OF this painting is in dispute. It is one of a series of panel paintings by Goya which hang in the Academy of San Fernando in Madrid. Goya may have been referring to these pictures in a note of 1793 in which he said that, in order to recover some of the great costs of his recent illness, he was painting 'a set of pictures in which I have succeeded in giving observation a place usually denied it in works made to order'. The works were intended to be 'popular in appeal'. The style and technique of this picture would seem to date it to much later in Goya's working life, and the subject is undoubtedly 'popular'. The setting is a village square, and the bullfight taking place is distinctly rustic in style. It is a picture full of life and movement.

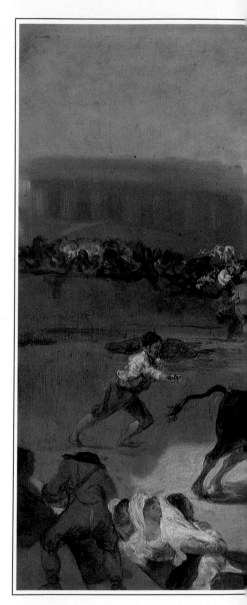

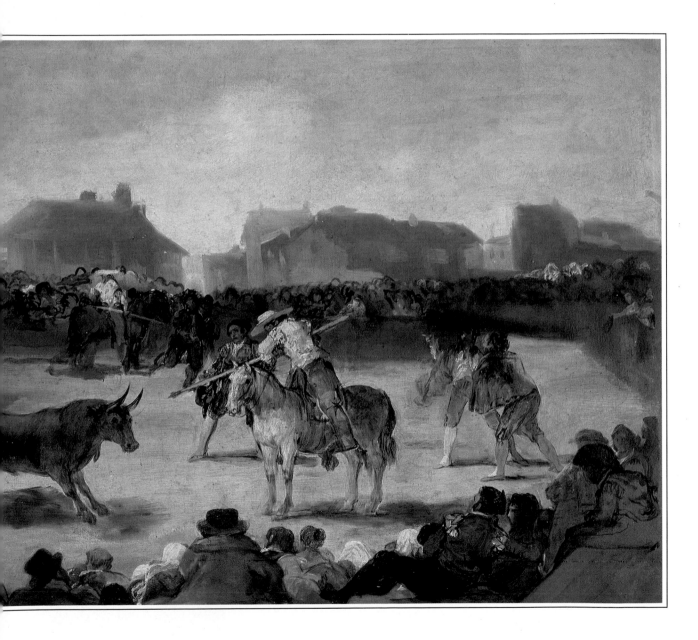

▷ A Dead Turkey 1808-10

Oil on canvas

THIS STILL-LIFE probably dates from the end of the first decade of the 19th century, when Goya was experimenting with this, for him, unusual art form, painting numerous *bodegones* ('kitchen still-lifes'), done for his own satisfaction and not as commissioned works. It is a remarkably uncompromising study of a dead bird; despite the fact that the picture is said to have been given to a friend as a Christmas present, Goya seems to be emphasizing the darker side of providing food for people, with the turkey displayed as a horribly dead object. Perhaps he was not thinking of the turkey as food at all, but rather as another corpse, like the many he had seen as a result of the war which was tearing Spain apart at the time.

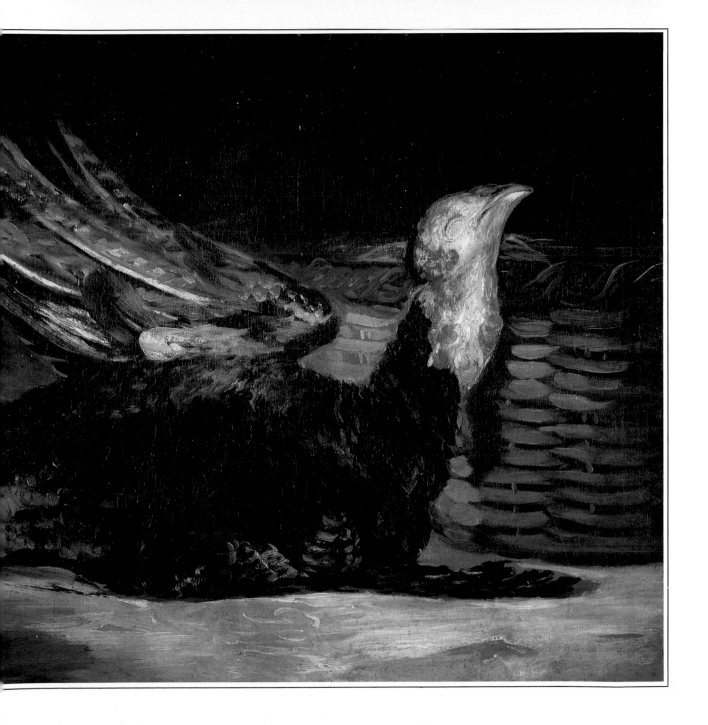

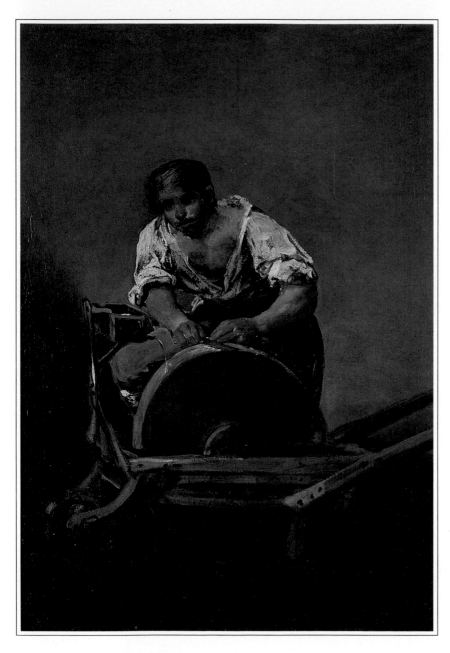

◁ **The Knife Grinder** 1810-12

Oil on canvas

UNLIKE SOME OF his earlier pictures depicting the working people of Spain going about their various tasks, this picture, and its companion picture, *The Water Carrier,* are more like portraits in formal style of the workman (or woman, in the case of the latter picture) than a study of the work being carried on. The paintings are thought to be connected to a cycle of drawings Goya was doing in around 1810, in which he was recording the behaviour and dress of people in everyday life. Both paintings show Goya using his paint thickly and in broad brushstrokes, perhaps because he was painting over old canvases: X-rays have revealed the remains of flower still-lifes beneath the Knife Grinder and the Water Carrier.

▷ **A Prison Scene** 1810-14

Oil on tin plate

THE TURMOIL and repression going on in the political life of Spain after the French invasion of 1808 seems to have been mirrored in Goya's work of the time. Again and again among his drawings and paintings of the period are found scenes done in a narrow range of dark hues and tones, dominated by dark areas of gloom pierced by shafts of misty light. There are terrible drawings of crimes, including murder and robbery, and scenes set in madhouses or prisons. The figures in this painting, some in chains, some naked, as if they were mad people rather than prisoners, are similar to others in etchings made by Goya around this period.

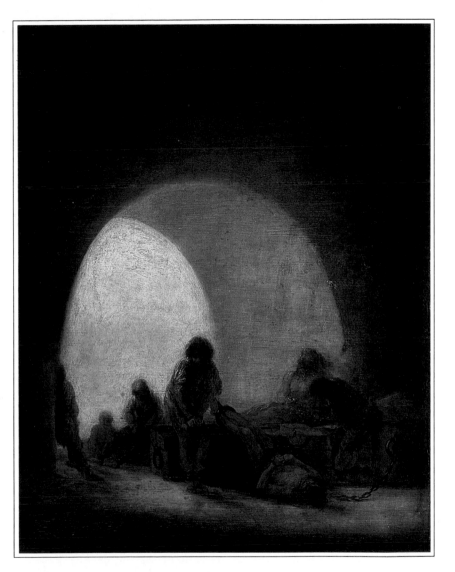

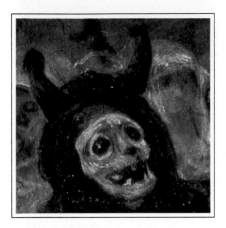

Detail

▷ **The Burial of the Sardine** c.1812-19

Oil on wood panel

VARIOUSLY DATED around 1793, 1800, and as late as 1820, this disturbing picture, with its scene of festivity overshadowed by grotesque images of witchcraft and monsters, depicts the mock funeral which traditionally ended the Corpus Christi Festival in Madrid on Ash Wednesday. The dancers are able to mock Death from the shelter of the anonymity given them by their masks. Despite the vivid white of the dresses worn by the women in the foreground (the high-waisted style of which suggests a later rather than earlier date for the picture), the dominant mood here is black; it is a scene of frenzy rather than jollity, of a hectic rather than innocent celebration.

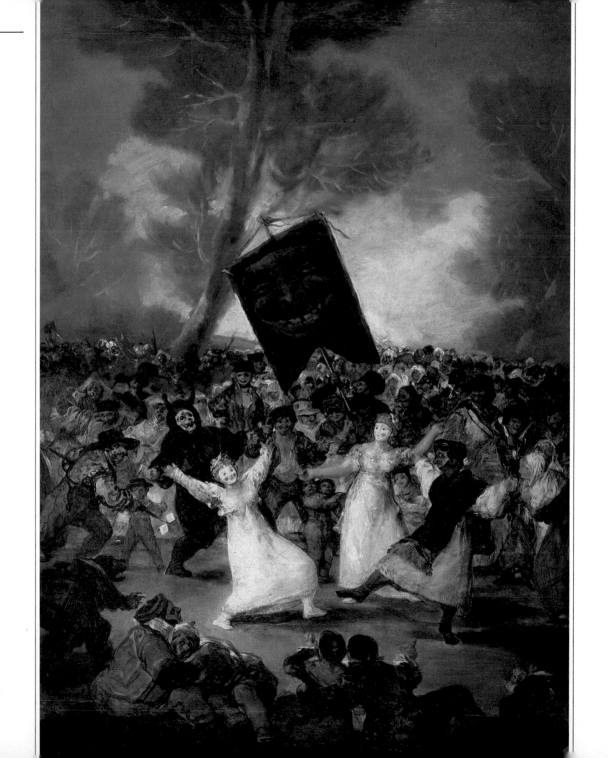

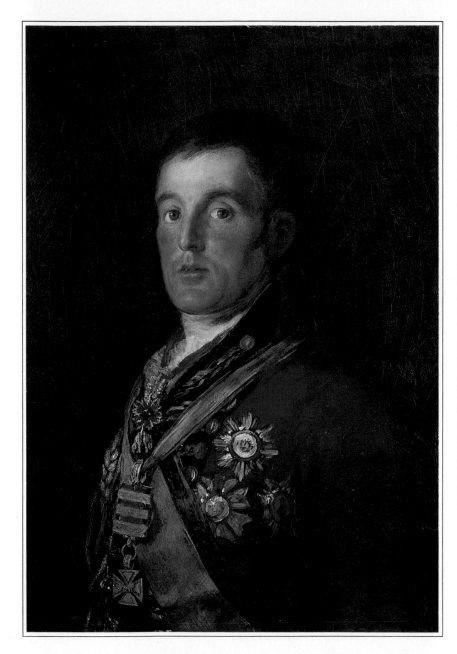

◁ **The Duke of Wellington**
1812

Oil on wood panel

BRITAIN'S GREAT GENERAL,
Arthur Wellesley, who had
been fighting his way through
Portugal and Spain since 1809,
driving the French before him,
had been made an earl a few
months before his triumphant
entry into Madrid in August
1812. Goya is believed to have
painted this famous portrait in
that month, though two years
later he was still tinkering with
the orders and decorations,
which were showered on
Wellington by grateful
governments and which Goya
never did manage to include
correctly. Wellington, who had
been made a duke in 1814, is
thought not to have been
entirely satisfied with the
portrait and gave it to a distant
relation. It was sold to the
National Gallery in 1961, was
stolen shortly afterwards and
was recovered in 1965.

▷ **Old Women** 1812

Oil on canvas

IT IS NOT OLD age that Goya is
mocking in this satirical
picture, but the vanity of old
age. The two crones, dressed
in clothing more suited to
innocent young girls, gaze at
their reflection in a mirror, on
the back of which is written
'Que tal?' – ('Can this be me?')
One the old women may be
wearing a bejewelled arrow –
Cupid's dart – in her
improbably blonde hair, but it
will be Time, leaning over her
shoulder with a broom in his
hand, who will have the final
say as to her inevitable destiny,
not Cupid.

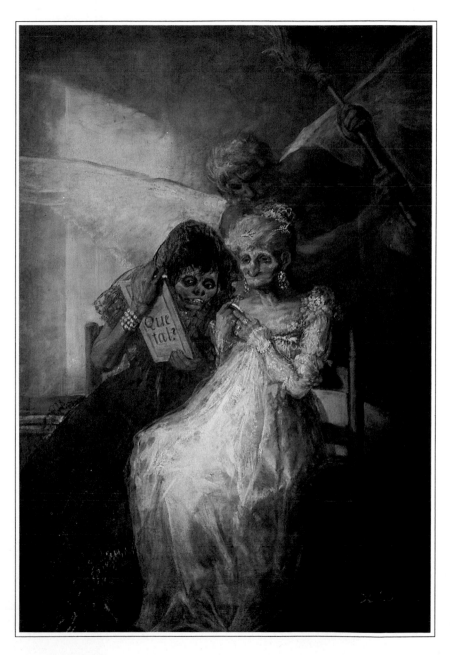

▷ **The Second of May, 1808:
The Riot Against Marmeluke
Mercenaries** 1814

Oil on canvas

THE INCIDENT which sparked
off guerilla warfare in Spain
took place in Madrid in May,
1808, and Goya made copious
notes of it and of the tragic
reprisals of the following day.
He carried his thoughts of the
terrible events in his head for
six years before he turned his
drawings into two superb
paintings. This one depicts the
revolt of the people of Madrid
against the French, who had
just forced Ferdinand VII to
retire to Bayonne, on 2 May
1808. The French general,
Murat, sent in his cavalry
against the largely unarmed
inhabitants to put down the
revolt. Goya's portrayal of the
event is a tangle of men and
horses, whirling across the
canvas and depicted in a storm
of brushstrokes of vivid,
violent colours.

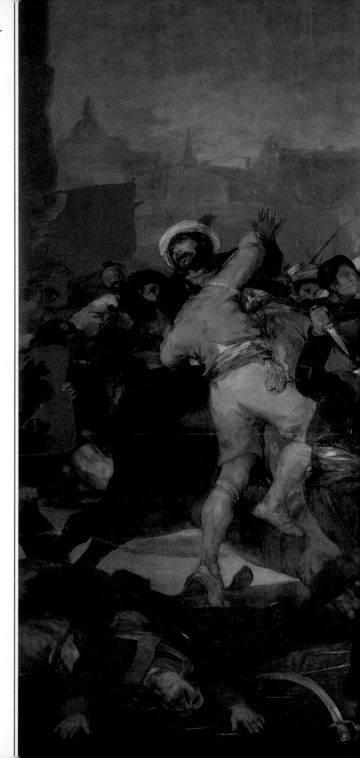

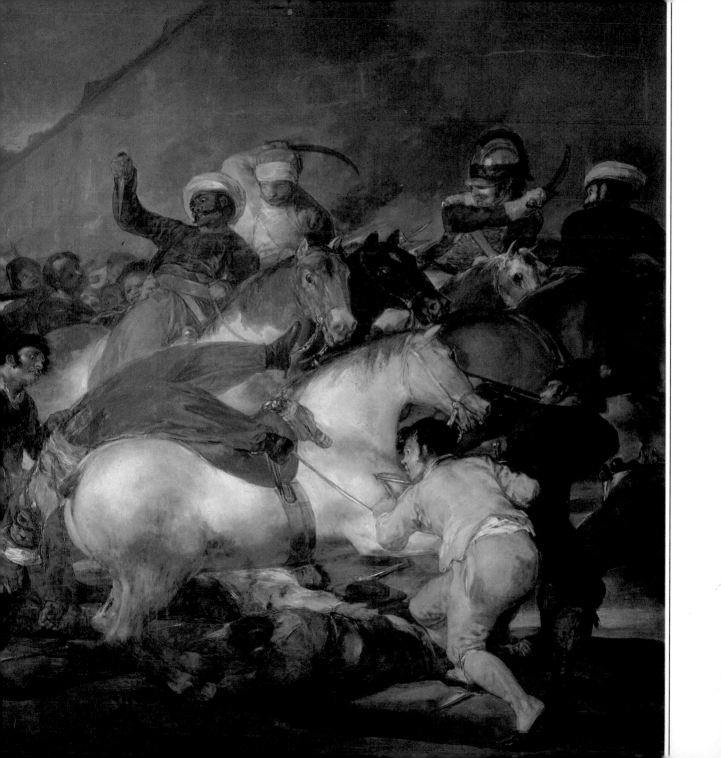

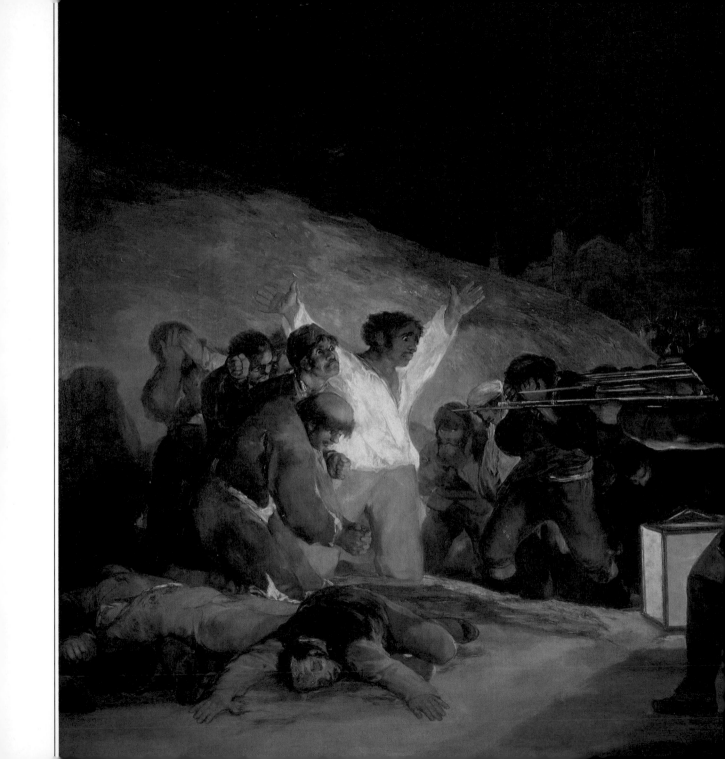

◁ **The Third of May, 1808: The Execution of the Defenders of Madrid** 1814

Oil on canvas

THE FRENCH CARRIED out severe reprisals against the people of Madrid in 1808. The day after the revolt, mass executions were carried out in Madrid, with about a hundred ordinary people being shot: 'Peasants – our common enemy,' wrote Murat dismissively. Goya's painting of the executions ranks with Picasso's *Guernica* as one of the greatest cries against the horrors of war ever made by an artist. Abandoning the vivid colours of *The Second of May, 1808,* Goya uses dark browns, greys and greens as the background for his dramatic depiction of an execution in the dead of night. The executioners are faceless; the faces of those about to die are lit by a lantern set at the soldiers' feet. The central, white-shirted figure has flung up his arms in a gesture, half of defiance, half of despair. It is a tragic, unforgettable image.

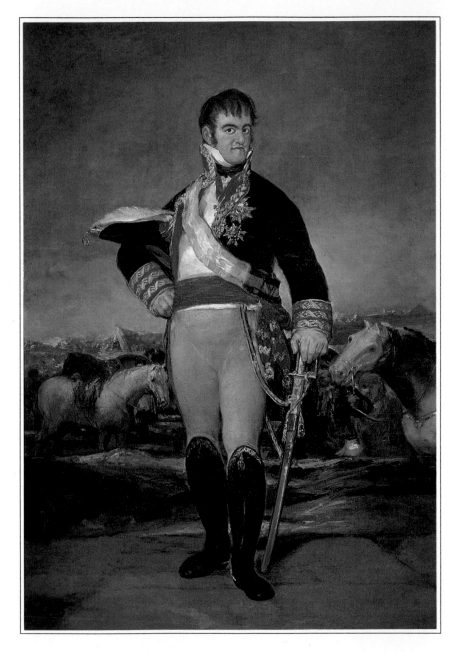

◁ **Portrait of Ferdinand VII**
1814

Oil on canvas

FERDINAND VII succeeded to
the Spanish throne in 1808,
after his father, Charles IV, was
deposed by Napoleon.
Ferdinand's own initial tenure
of the throne was brief, as
Napoleon imprisoned him and
gave the throne of Spain to his
brother, Joseph. It was during
Ferdinand's first period as
King of Spain that Goya made
the only sketches of him he
was ever to do. His several
later portraits of the
Ferdinand, including this one
which dates from the year of
his restoration, were all done
from the sketches of 1808. Not
surprisingly, the king looks
almost exactly the same in all
Goya's portraits of him; only
the uniform changes
sometimes. Ferdinand seems
to have been little interested in
Goya's art, but continued to
pay the artist's generous
pension, even in the last years
of Goya's life, when he did
little to earn it.

▷ **Self-portrait** 1815

Oil on canvas

THERE ARE TWO versions of
this, probably the best-known
of Goya's portraits of himself.
This one, now in the Prado in
Madrid, is the smaller of the
two and may have been a
preliminary study, indicating
the care Goya put into this
deeply personal work. Critics
have pointed out that he has
probably depicted himself as
looking rather younger and
less careworn than in reality at
the time. He was nearly 70
now, not in the best of health
and had been living a solitary
life since the death of his wife
in 1812. Or perhaps he had
not. His young housekeeper
and distant relative, Leocadia
Weiss had given birth to a
daughter, Rosario, in 1814,
although she had been
separated from her husband
for some time. Although the
child's parentage has never
been proved, it is thought
likely that Goya was, in fact,
the father.

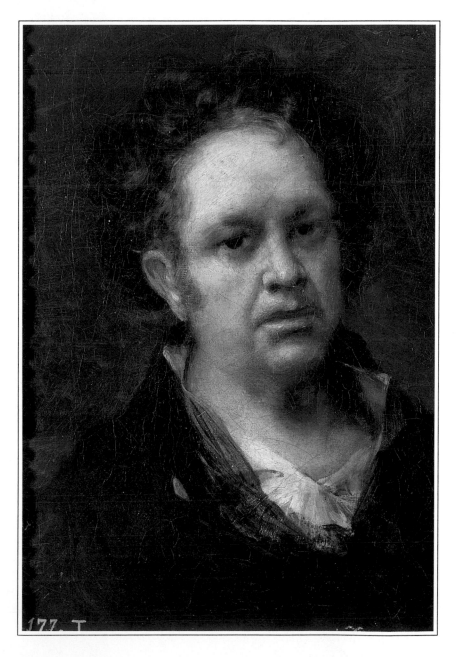

▷ The Court of the Inquisition 1815-19

Oil on wood panel

ONE OF THE BETTER moves made by Napoleon in Spain was to abolish the notorious Spanish Inquisition. Ferdinand VII resurrected it on his restoration in 1814 though, to judge from Goya's couple of brushes with it, which seemed to have no adverse effect on his position, it had long lost much of its importance. This study of the Inquisition at work questioning a 'victim' may have been born of Goya's own sense of outrage at having his work questioned by such an organization. The details in the picture are more likely to have come from Goya's study of published reports of the work of the Inquisition, than from actual experience. In 1812 he had painted the portrait of Juan Antonio Llorente, former Secretary General of the Holy Office, who had published in Madrid an account of the Inquisition in which he had criticized its activities.

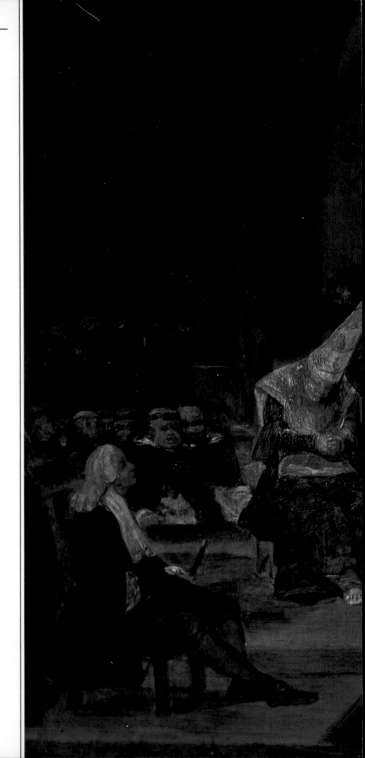

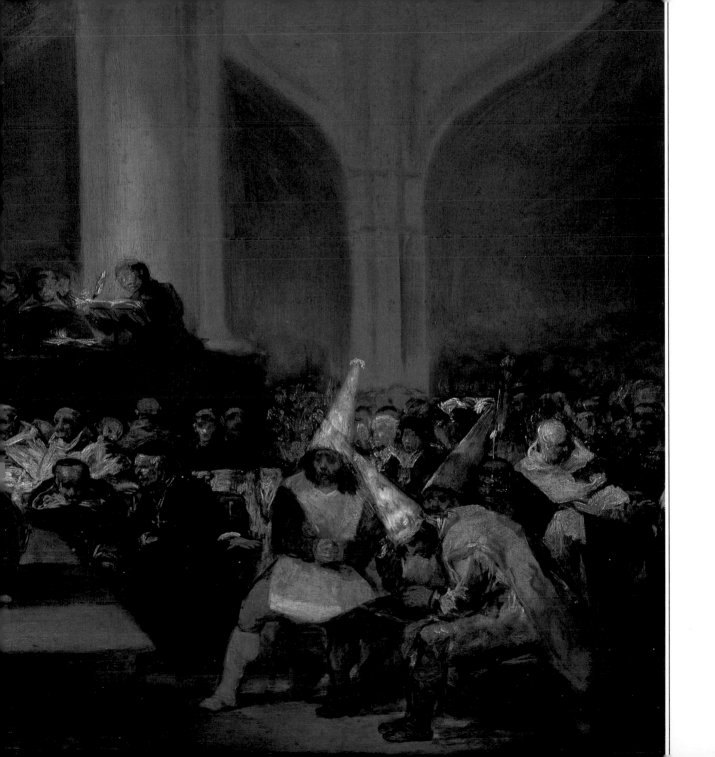

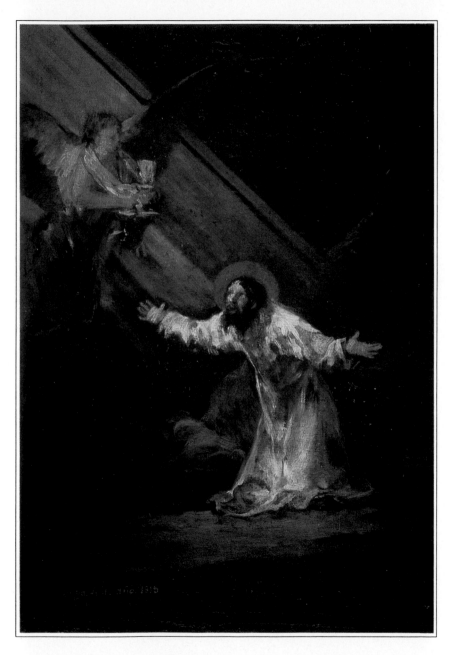

◁ The Agony in the Garden
1819

Oil on wood panel

IN 1819, THE increasingly reclusive Goya was commissioned to paint *The Last Communion of St Joseph of Calasanz* for the Church of San Antón in Madrid. With this masterpiece, Goya displays, for the first time in his life, an intensely felt identification with the mysteries of the faith at the heart of Catholic Christianity. This intensity remains in *The Agony in the Garden* (also known as *Christ on the Mount of Olives*), a smaller picture which Goya painted at the same time. It is painted with great freedom, the pale-robed figure of Christ, his arms outflung in a way reminiscent of the central figure in *The Third of May 1808,* dramatically emphasized in the picture by the deep shadows which surround him.

▷ **The Agony in the Garden**
(detail)

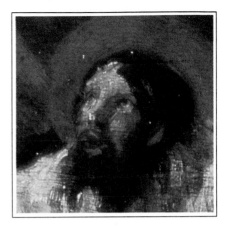

ANDRÉ MALRAUX writing an
essay on Goya and his art in
1957, said that Goya 'did not
anticipate any one of our
present-day artists – he
foreshadowed the whole of
modern art.' It was Goya's
freedom of expression and the
power with which he painted
that were uppermost in
Malraux' mind as he wrote.
Certainly, the extraordinarily
expressiveness of Goya's
brushstrokes as he painted the
face of Christ in *The Agony in
the Garden* seems to be as
powerful as anything
produced in the twentieth
century.

▷ The Procession of the Flagellants c.1815-20

Oil on wood panel

PUBLIC FLAGELLATION as an inspiring expression of religious fervour had been a feature of Spanish life from the 16th century, though by Goya's time it had lost much of its popularity, suggesting that Goya may have painted this lively scene as an illustration of life in past times in Spain, rather than as a record of something he had actually witnessed. He has set his group of flagellants firmly in the centre of a Holy Week procession, with a statue of the Virgin, carried on the shoulders of a group of priests, dominating the scene.

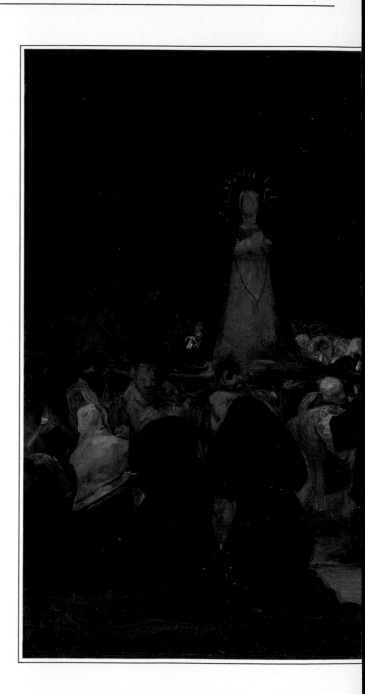

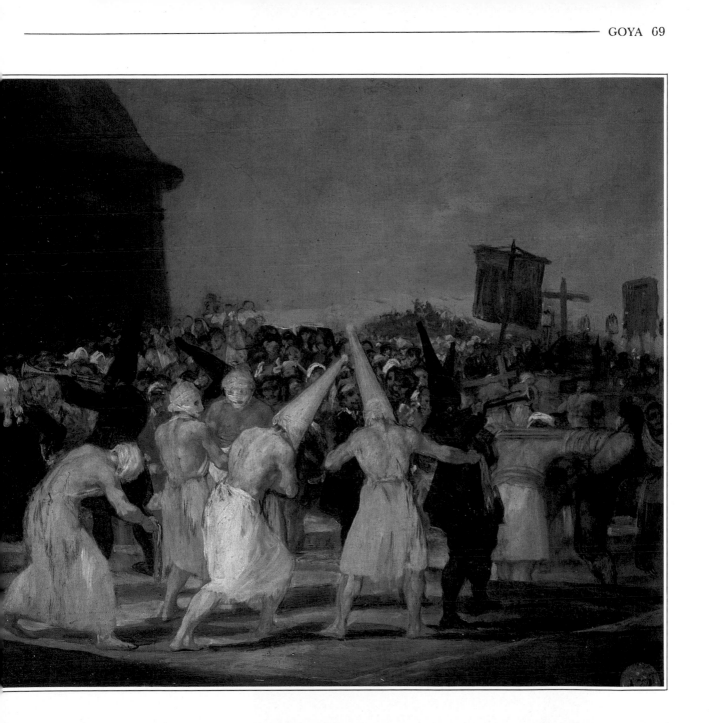

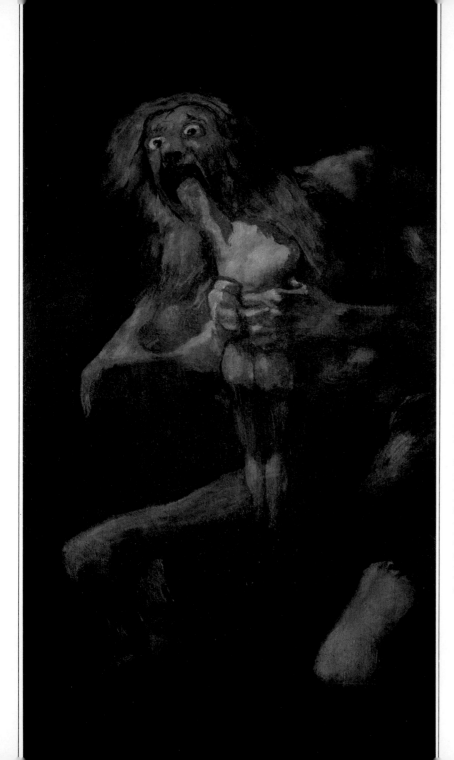

◁ **Saturn Devouring One of His Children** 1820-3

Oil on plaster, later transferred to canvas

ORIGINALLY PAINTED by Goya on a wall in his house, the Quinta del Sordo ('House of the Deaf Man'), just outside Madrid, this nightmarish picture seems less a recreation of a mythological tale – the god Saturn was supposed to have devoured his sons because he was jealous of their probable power when grown to manhood – than a comment on the madness and ignorance of old age. Goya is believed to have based his picture on one of the same subject by Rubens, painted at a time when Saturn was included in emblem books as a symbol of the burdensome nature of old age. Goya's picture is one of the famous series of fourteen 'black paintings' with which he decorated the walls of two of the main rooms in his new house, his Spanish home during the last years of his life.

▷ **A Fantastic Vision** (detail)
1820-3

Oil on plaster, later transferred
to canvas

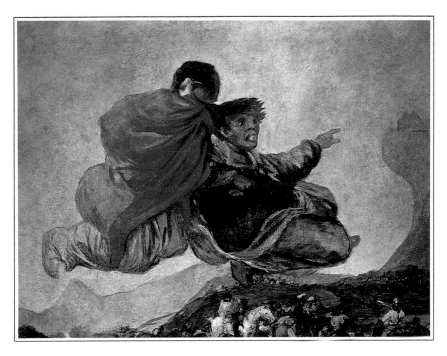

ANOTHER OF THE 'black
paintings' from the upper
room of Goya's house, the
Quinto del Sordo, this strange
vision dates from a time after
Goya's serious illness of 1819
which had such a profound
effect on his mental state. His
waking hours haunted by the
fantastic nightmares which
disturbed his sleep, Goya took
to recording his memories of
them on the inner walls of his
house. Perhaps it was a form of
catharsis which kept him sane.
Whatever the reason for these
paintings, they have come
down to us as some of the most
extraordinarily mysterious
paintings every produced by a
great artist. Goya did not
name any of the paintings, but
their contents recalled themes
of earlier work. In this one,
Goya has inserted a fantastical
landscape, peopled with small,
scattered figures and with two
giant flying figures (are they
witches, flying to a sabbath?),
recalling *The Colossus*. In the
complete picture, the witch
figures are themselves
menaced by an armed soldier
who appears to have come
from the execution squad in
The Third of May, 1808.

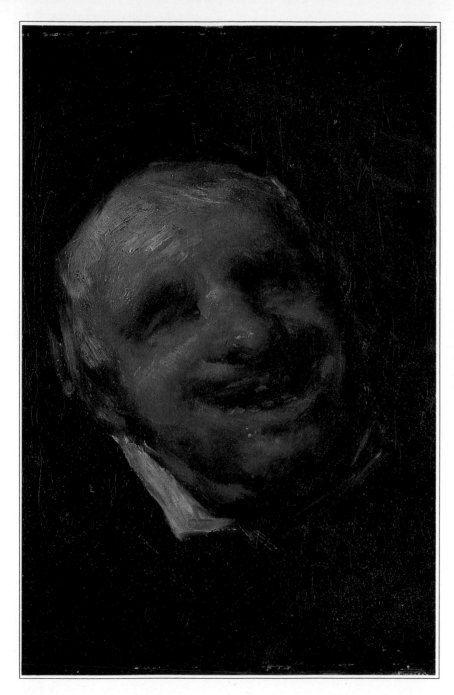

◁ Tio Paquette 1820-3

Oil on canvas

THE ANGLE OF the head in this portrait recalls Goya's self-portrait of 1815, but the treatment of the subject has become more satiric, less good-humoured. The portrait is believed to be that of a beggar, singer and guitar player well-known in Madrid for his performances outside the Church of San Felipe. Goya included a singer and guitar player in another of the 'black paintings' of this period, *The Pilgrimage to the Pool of San Isidro,* the model for which could well have been Tio Paquette again.

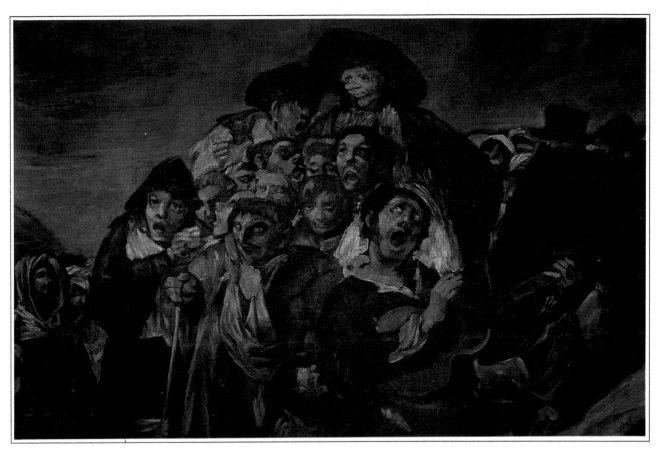

△ **Pilgrimage to the Pool of San Isidro** (detail) 1821-3

Oil on plaster, later transferred to canvas

GOYA'S 1788 PAINTING *The Meadow at San Isidro,* was a light-hearted, sun-lit picture of people enjoying themselves during Madrid's annual fiesta dedicated to its patron saint, St Isidro. Nearly 40 years later, when he returned to the subject, his mood had darkened and the 'black painting' he added to the collection on the walls of his house depicted a crowd of black-robed, wild-eyed grotesques, their mood anything but sunny as they processed, headed by a blind guitarist (the blind leading the blind?) – to the pool of San Isidro.

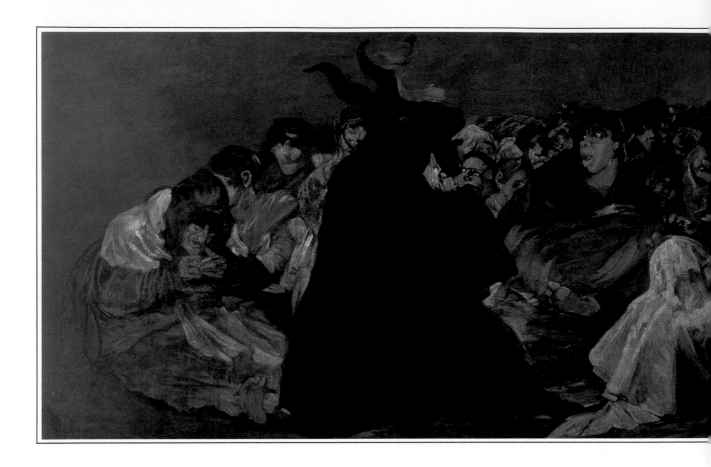

△ The Witches' Sabbath, or the Great He-Goat c.1821-3

Oil on plaster, later transferred to canvas

GOYA WAS RETURNING to an old theme in this picture, another of the 'black paintings' from the Quinta del Sordo. Goya had shown an interest in witchcraft back in the 1790s, most notably in the picture, *Scene of Witchcraft,* in which a great he-goat, his horns garlanded with twigs of laurel, sat in the centre of a circle of witches. Although a night-time scene, moonlight had given the picture an attractive silveriness. With this 'black painting', the mood has become blacker, more menacing and very

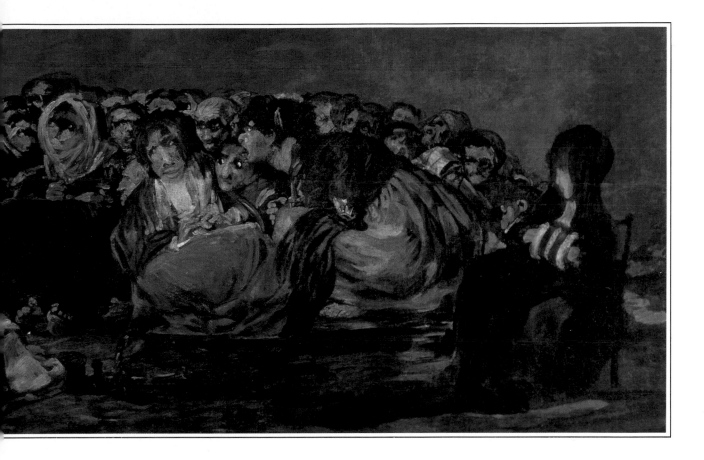

disquieting. There is still a
great strength about the
painting, however; it
proclaims not defeat, but the
artist's strength of body and
of spirit.

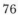 **The Bullfight** c.1825

Oil on canvas

GOYA RETAINED HIS interest in the bullfight to the end of his life. This oil, probably painted while Goya was living in Bordeaux where the 78-year-old artist had fled in June 1824, may have been a study for a scene in his last series of bullfighting prints. In 1816, Goya had advertised *La Tauromaquia,* a series of 33 prints which 'represent different *suertes* (actions) of the art of bullfighting'. Nine years later came *Bulls of Bordeaux,* a set of lithographs published in Bordeaux. Goya was one of the first European artists to experiment with the comparatively new graphic process of working on lithographic stone. Despite the great quality of Goya's bullfighting lithographs, there was little public demand for them at the time.

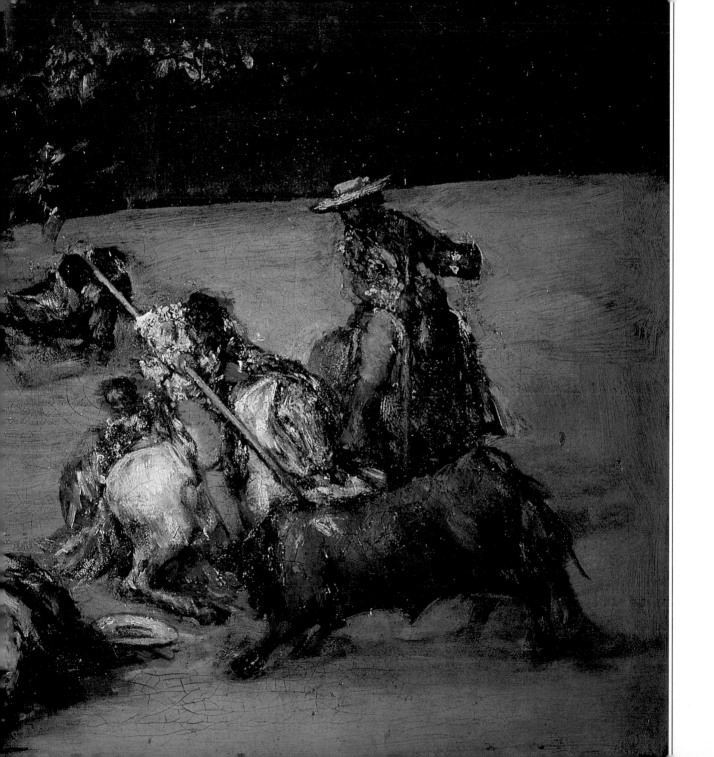

◁ **The Milkmaid of Bordeaux**
1827

Oil on canvas

THIS BEAUTIFUL study of a young girl, painted in Bordeaux when he was over 80, has been called Goya's 'farewell to colour and beauty'. With it, he put behind him the nightmarish visions of the Quinta del Sordo and set aside his recent preoccupation with drawing and print-making. Athough details of the painting, especially the girl's headscarf and shawl, suggest earlier pictures of *majas* and of such working girls as the *Water Carrier*, the overall tone is much more gentle, even innocent. The light that Goya brought into his picture, caressing the girl's cheek and shoulder and shimmering behind her head, prefigured the Impressionists. Half a century later, Monet and Sisley would be searching for ways of achieving this effect, and Renoir would be painting girls with just this combination of rich yet tender tone and luscious charm.

ACKNOWLEDGEMENTS

The publisher would like to thank the following for their kind permission to reproduce the paintings in this book:

Bridgeman Art Library, London/**Prado, Madrid**: 8-9, 10, 11, 12, 13, 18-19, *20*, 21, 22-23, *24*, 25, 26, 28, 35, 42-43, 44-45, *46*, 47, 50-51, *54*, 55, 58-59, 60-61, 62, 63, 70, 71, 73, 74-75, 76-77; /**Prado, Madrid**/**Index, Barcelona**: 78; /**Private Collection**: 16, 37; /**Louvre, Paris**: 27; /**Palacio de Liria, Madrid**: 30 *(also used on front cover, back cover detail and half-title page detail)*; /**Academia de San Fernando, Madrid**: 31, 40-41, 48-49, 64-65, 68-69; /**Courtauld Institute Galleries, University of London**: 32; /**National Gallery, London**: 33, 56; /**Fondazione Contini-Bonacossi, Florence**: 38; /**Museum of Fine Arts, Budapest**: 52; /**Bowes Museum, Co. Durham**: 53; /**Musée des Beaux-Arts, Lille**/**Giraudon**: 57; /**Colegio Escolapios de San Anton, Madrid**/**Index, Barcelona**: 66, *67*; /**Thyssen-Bornemisza Collection**: 72;

NB: Numbers shown in italics indicate a picture detail.

Every effort has been made to trace the copyright holders and we apologise in advance for any unintentional omissions. We would be pleased to insert the appropriate acknowledgement in any subsequent edition of this publication.